EXTREME EXPOSURE

EXTREME EXPOSURE

Pushing the Limits of Aperture and Shutter Speed for High-Impact Photography

DAVID NIGHTINGALE

AMPHOTO BOOKS

an imprint of the Crown Publishing Group
New York

Published in the United States by
Amphoto Books, an imprint of the
Crown Publishing Group, a division
of Random House, Inc., New York

www.crownpublishing.com

www.amphotobooks.com

AMPHOTO BOOKS and the Amphoto Books
logo are trademarks of Random House, Inc.

Originally published in Great Britain as
Extreme Exposure by Ilex, an imprint of
The Ilex Press Limited.

This book was conceived, designed,
and produced by The Ilex Press Limited,
210 High Street, Lewes, BN7 2NS, UK

Library of Congress Control Number:
2009926713

ISBN: 978-0-8174-3967-5

Printed in China

Color origination by Ivy Press Reprographics

First American Edition

10 9 8 7 6 5 4 3 2 1

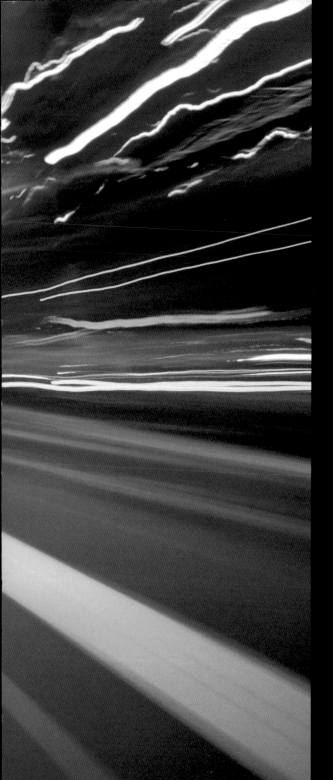

CONTENTS

Introduction

There has never been a better time to be a photographer: Digital cameras are relatively cheap in terms of both initial purchase and day-to-day use, they are easy to operate, and even the most basic point-and-shoot camera is capable of producing excellent results. And if you want to graduate to a digital SLR there's no longer the steep learning curve that was required in the days of film-based photography—an SLR may be bigger and offer more features, but even some of the most advanced models can be switched to Auto so you can just "point and shoot."

With such fantastic ease of use, it's hardly surprising that more people than ever now shoot with a digital SLR, but for some photographers the exploration of their camera ends with the mode dial set permanently to Auto, and the camera calling the shots. Admittedly, a lot of the time these cameras are capable of making great split-second decisions about things like focus, exposure, and white balance—sometimes better decisions than the person looking through the viewfinder. But this doesn't mean they're infallible. Sometimes even the most expensive digital SLR will get it wrong, either being fooled into making a genuine mistake or simply because it's programed to take *a* shot, but not necessarily the *best* shot, let alone the shot *you* wanted.

So what can you do if there's something you don't like about a particular picture? What can you do if the background is distracting, the action you were trying to capture is just a blur, or the image is under- or overexposed? Unfortunately, if you're relying on the camera to make all the decisions for you the answer is "not much." You can try taking the shot again, or change something about the scene you are photographing, but if control over the photographic process is in the hands of the camera you have to accept the result it decides on. While it will do its best to make sure you get a reasonable shot, this isn't guaranteed.

Of course, a lot of photographers are happy to explore the other settings their camera has to offer, and most of us want to get more involved in the decision-making process—it's part of the fun and the challenge of photography. By far the most significant step you can take is to get "hands on" with the exposure. Whether it's setting the aperture, the shutter speed, the ISO—or all three—exposure is the fundamental building block of any photograph, and the one thing that will instantly give you the most control over the pictures you produce.

But even after you take charge of your exposures, it's easy to find yourself suffering from "f/8 @ 1/125 sec syndrome," where each shot is approached with a safe aperture and a safe shutter speed that you know will give good results most of the time. There's nothing wrong with this—a good result is what most people are after—but relying on a formula is no different from relying on the camera's Auto mode; creative thinking is being replaced with a "mechanical," rule-abiding approach to photography. Sure, you'll get a shot, but are you getting the *best* shot? The shot you were aiming for?

This book is about forgetting your camera's Auto mode: Ignore the rules that say you should choose a "safe" aperture and shutter speed, and try something a little more extreme! Taking a more extreme approach to exposure can unshackle your photography and refresh your approach to picture making. Not only that, but with a digital camera an extra shot won't cost you anything except a moment of time and a tiny amount of space on your memory card. Most important, it could mean you aren't just taking good photographs, you're creating great ones!

1. TECHNICAL CONSIDERATIONS

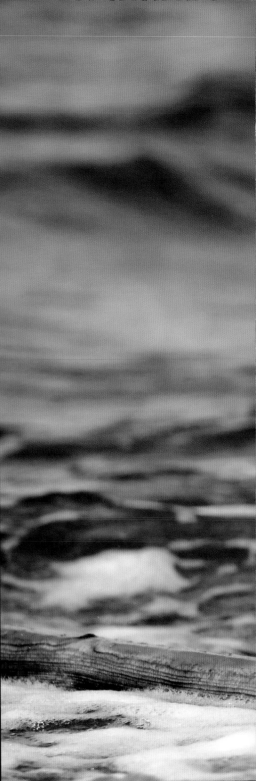

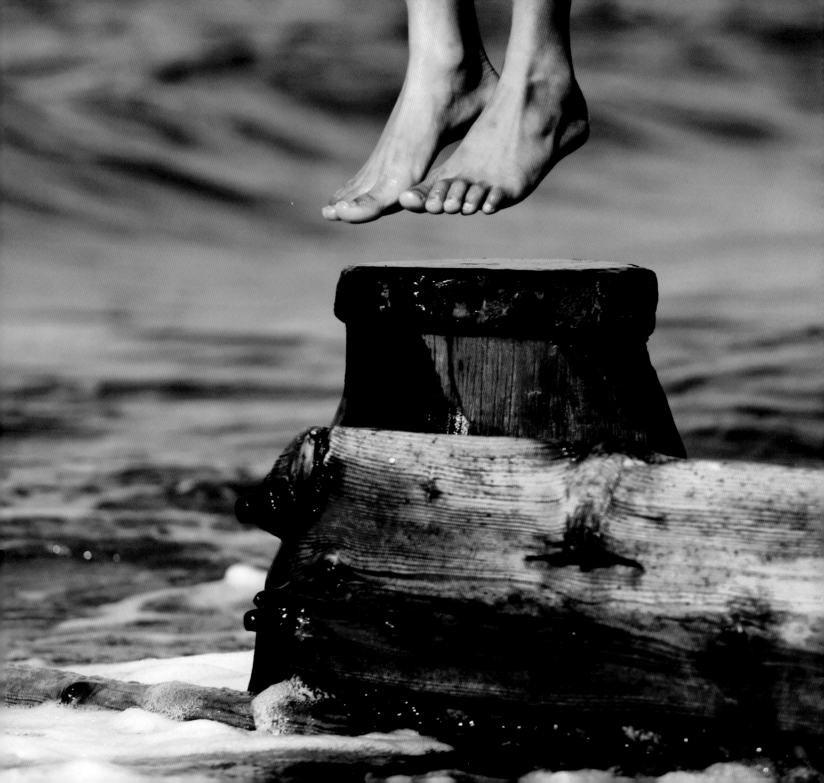

Cameras and equipment

What type of camera do you need?

While many of the techniques that we will cover later in this book can be performed with any camera, there are some limitations if you are shooting with a point-and-shoot model instead of a digital SLR. The most significant of these is that the majority of point-and-shoot cameras restrict the maximum shutter speed to around 15 seconds, possibly less. For low light photography this isn't an especially significant issue, but if you are interested in shooting ultra-long exposures (night shots and star trails, for example), an SLR with a Bulb setting is a much better option.

A second limitation is that most point-and-shoot cameras don't have a hotshoe, so you can't attach an external flash. Again, for the majority of picture-taking situations this isn't a problem, but if you are interested in exploring ultra-short exposures with flash, you'll need a point-and-shoot with a hotshoe, or an external flash with a slave cell that can be triggered by the camera's built-in flash.

Finally, the aperture on a point-and-shoot camera can also be a limiting factor if you want to minimize the depth of field. Because of their small sensor size, the depth of field will be greater on a point-and-shoot camera than it is on an SLR, even if they're both set to a wide aperture such as f/4. As a result, you might struggle to isolate a subject from its background, or selectively blur an image, unless the subject is very close to the camera. In all of these instances, a digital SLR is more versatile as it gives greater control over the shutter speed, aperture, and flash.

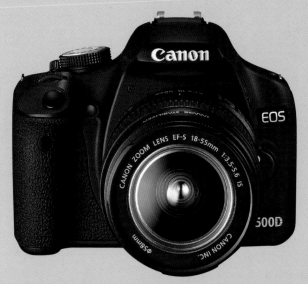

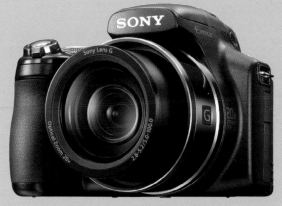

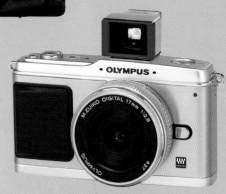

top to bottom:

Digital SLR: The most versatile type of camera for "extreme" photography is a digital SLR that gives you full control over the aperture and shutter speed, as well as letting you use a wide range of lenses and accessories.

Superzoom: A superzoom camera typically offers comparable control to a digital SLR, but the fixed lens and small sensor can mean it's hard to minimize the depth of field.

Point-and-shoot: High end point-and-shoot cameras are getting more and more sophisticated. This Olympus camera has similar controls and the same size sensor found in Olympus' digital SLRs. It even has interchangeable lenses.

AVOIDING BLUR: MIRROR LOCK-UP

During a normal exposure with a digital SLR, pressing the shutter triggers a sequence of events. It starts with the reflex mirror swinging out of the way for the shutter to open—a movement that can cause minor camera shake. This is why some digital SLRs offer a mirror lock-up function, which is normally available through one of the menus or custom functions. This feature lets you lock the mirror up *before* you take a shot, so there's no chance of camera shake caused by the mirror when you actually take your picture. Use mirror lock-up with a remote release and a tripod for the sharpest possible result.

What other equipment do you need?

For most of the techniques in this book you will require little more than your camera. For some you'll need a lens suited to the specific task, or possibly an external flash, but most times the camera you've already got will be enough. That said, there are some other items you will find useful.

If you plan on shooting long exposures, for example, and don't want to introduce any accidental (or deliberate) blur, then a tripod should be at the top of your shopping list. More than any other accessory, tripods can vary hugely in price—some cost very little, while others can cost as much as a camera. Generally speaking, you get what you pay for, and more expensive tripods offer better stability, more versatility, and are more robustly made than cheaper models. A budget tripod might perform reasonably well with relatively short exposures in calm weather, but if the wind is blowing and/or you are attempting to shoot an exposure of several seconds or longer, you might find you would be better off holding the camera yourself!

In addition to a tripod, a remote shutter release is also going to be useful. A remote release lets you to trip the camera's shutter without touching the camera itself, reducing the risk of camera movement and helping you produce sharper images. Most times a relatively inexpensive release will suffice, but if you have the budget it's worth taking a look at

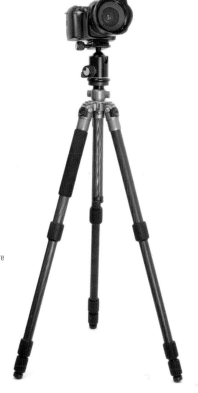

A tripod is essential for photographs that require a long exposure, and the more you spend, the stronger, more versatile, and more robust it is likely to be.

the more expensive types: There are some, for example, that will let you program long exposure times, which is much easier than timing a Bulb exposure manually.

Other items you might find useful include neutral density (ND) filters for extending your exposures, a hotshoe-mounted level for keeping your horizon straight (especially at night when you can't actually see it), and a flashlight, again for working in low-light conditions when you might not be able to see your camera settings. The level means you can set up your camera in the dark when the horizon may not be visible, without suffering from a sloping sky in the final photograph, while a flashlight will simply let you see your camera so you know what settings you are changing, and how.

above: Using a remote release will dramatically reduce the risk of camera shake as you trigger the shutter, especially if you combine it with a tripod and your camera's mirror lock-up.

above: Although you can straighten an image in an image-editing program, getting it right with a hotshoe-mounted level when you shoot is a much better option.

Exposure: An introduction

At it's most basic, exposure is a very straightforward concept—it's all about making sure the right amount of light reaches your camera's sensor. There are a variety of ways in which this can be achieved, which we'll look at shortly, but let's first take a quick look at why we need to understand this process.

In many ways, a digital camera's sensor operates in a similar way to the human visual system. Just as photons strike the retina in the human eye, so photons are collected by photosites on a sensor (rather like water drops falling into a bucket). In both cases, the resulting signal is sent to be processed—either by the camera's internal processor or the human brain—and the end result is an image.

Aside from the electronics involved in a camera, there is one significant difference between the two processes: The eye continually adjusts to varying levels of brightness, whereas the light-sensitivity of a camera's sensor is fixed during the period of exposure. So, in order to get the exposure "right" we need to make sure that the right amount of photons hit the sensor in order to accurately represent the scene. If there are too few photons, the scene will appear dark in the final image, but too many and it will appear overly bright.

To make things slightly more complicated, each photosite has a limited capacity, so it can only record a certain number of photons before it becomes "full." When it reaches its capacity it will output exactly the same signal each time (pure white in the image), irrespective of how many further photons strike it during an exposure—just as a bucket with a five-gallon capacity can only ever hold five gallons of water, regardless of how much water is consequently poured into it. Fortunately, to check the exposure all you need to do is assess the histogram on your camera's LCD display once you've taken a shot.

UNDERSTANDING HISTOGRAMS

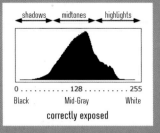

correctly exposed

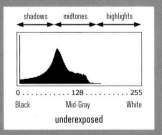

underexposed

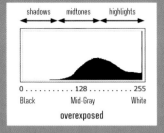

overexposed

A histogram is the most accurate exposure guide, whether you use the histogram on your camera or in an image-editing program. The histogram shows shadow detail at the left, midtone detail in the middle, and highlight detail to the right.

A correctly exposed image will usually have a good distribution of tones across the range, whereas an underexposed image will contain relatively little highlight detail and the shadow tones will often be bunched to the left. If the histogram hits the left edge of the scale, this indicates that no data has been collected in the darkest areas, and these will appear black in the final image.

With an overexposed image, the opposite happens—the histogram will be skewed to the right. If it hits the right edge, this means some photosites have received too much light and are completely full. These will appear as pure white pixels in the final image.

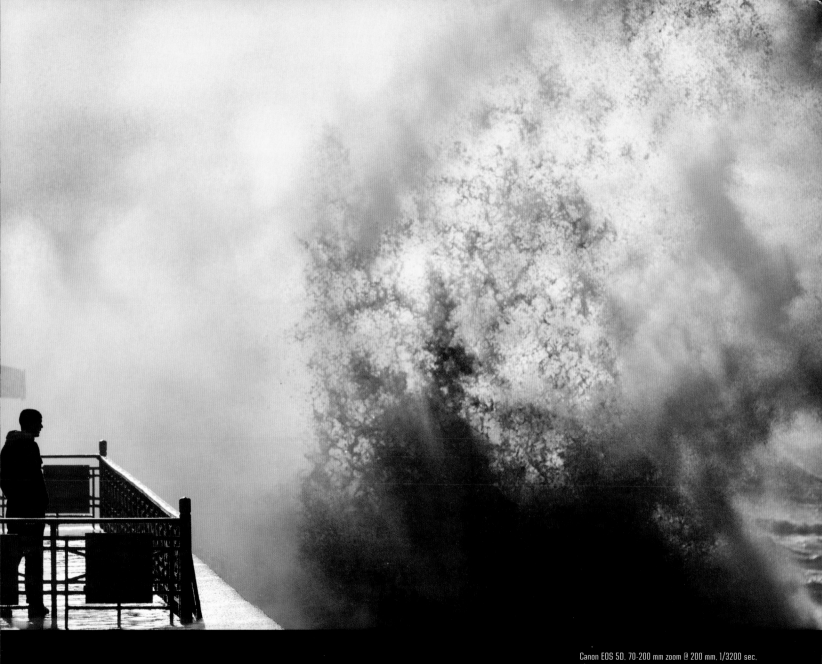

Canon EOS 5D, 70-200 mm zoom @ 200 mm, 1/3200 sec.
f/5.6, ISO 100

Exposure value

A term intrinsically linked to exposure is EV (short for Exposure Value), which relates to light intensity. An EV of 0 is the intensity of light required to correctly expose a neutral, 18% gray card (the default target for an exposure meter), using a 1 second exposure, an aperture of f/1, and a sensitivity setting of ISO 100. All other EVs are determined from that, ranging from EV -6 (a starlit night sky) to EV +20 (bright, specular highlights).

An EV step increase or decrease is a doubling or halving of the light intensity, so EV 2 is twice as bright as EV 1, and half as bright as EV 3, for example. In terms of real world exposures, an EV step is the same as adjusting the shutter speed, aperture, or ISO by one full stop. For example, a cloudy, bright scene will be around EV 13, which could be exposed at 1/125 sec, f/8, at ISO 100. However, if the cloud thickened, the EV would drop to 12. To compensate for this you could either increase the shutter speed by one stop (to 1/60 sec), open up the aperture by one stop (to f/5.6), or raise the ISO by one stop (to ISO 200). Either one of these would compensate for the decrease in the light intensity but, as we will see on the following pages, each of these fundamental exposure controls will affect the image in a different way.

So, there are ultimately two key factors that contribute to determining an exposure. The first of these is the EV of the scene—the amount of light reflected from the scene you are photographing—and the second is the combination of aperture, shutter speed, and ISO needed to allow sufficient light to reach your camera's sensor. The key thing to remember is that while the EV constrains the camera settings (in that you need to select a particular aperture, shutter speed, and ISO combination to get the right exposure), it doesn't actually determine any of the individual values. The same scene can be recorded using a wide range of apertures (providing the shutter speed and ISO are set accordingly), an equally wide range of shutter speeds (with a corresponding adjustment aperture and ISO), and at a choice of ISO settings (again assuming the aperture and shutter speed are set to keep the overall exposure balance). In this sense, any scene—no matter how bright, or how dark—offers a huge range of photographic possibilities, from the safe, to the "extreme." And that is precisely where the skill of the photographer comes into the equation.

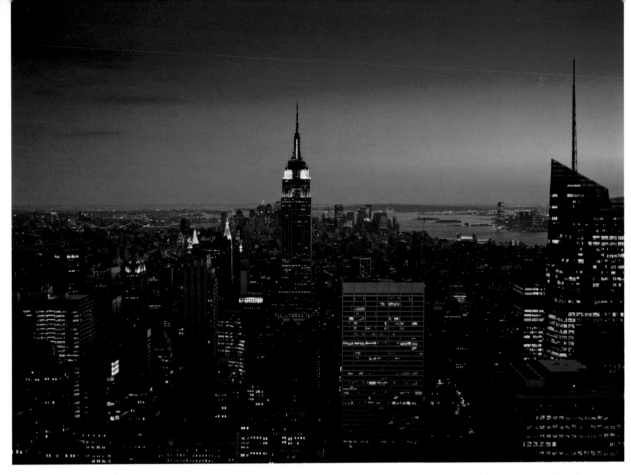

EXPOSURE VALUES AT 100 ISO

This list is a guide to illumination levels and their corresponding Exposure Value (EV) at an ISO 100 sensitivity setting. Each EV step increase means the intensity of the light doubles, while each single EV decrease means the light intensity is halved. This relates directly to a "stop" in terms of the aperture, shutter speed, or ISO.

EV	Typical subject
-6	Starlit night sky
-5	Crescent moonlight, faint aurora
-4	Quarter phase moonlight, medium intensity aurora
-3	Full moonlight, bright aurora
-2	Full moon light on a snowscape
-1–+1	Night-time city skylines (varying intensity of light)
+2	Distant lit buildings (at night)
+3–5	Indoors, low light

EV	Typical subject
+6–7	Home interior
+7–8	Bright street scenes, dawn and twilight
+9–11	Just before sunrise or just after sunset
+12	Heavily overcast, or open shade with sunlight
+13	Cloudy, bright with no shadows
+14	Hazy sunlight with soft shadows, or bright sun low in sky
+15	Bright sunlight overhead with sharp shadows
+16	Bright sunlight on snow or light sand
+17–20	Specular sunlight reflections, intense man made lighting

Controlling exposure: The aperture

The aperture is a hole inside a lens that can be varied in size to regulate the amount of light reaching the camera's sensor. A larger aperture allows more light to reach the camera's sensor, while a smaller aperture allows less light—it's that simple! However, once we start to look at it in more detail, things get slightly more complicated.

F-stops

The most common way to reference the size of the aperture is in f-stops, such as f/2.8, f/8, f/16, and so on, with a smaller number somewhat counter-intuitively indicating a larger aperture. This is because f-stops are written as the ratio of the focal length of the lens to the maximum size of its aperture. For example, if a 50 mm lens had an aperture measuring 50 mm in diameter it would have a maximum aperture of f/1 (50/50). However, if the maximum size of the aperture was 25 mm, the maximum f-stop would be f/2 (50/25). Drop the size of the aperture to 12.5 mm and the maximum f/stop becomes f/4 (50/12.5), and so on.

Now, just to confuse things, an aperture of f/2 is not half the size of an aperture of f/1—it is a quarter of the size. Although the diameter of the aperture has been halved, the area of the hole has actually been quartered. Therefore, an aperture of f/1 allows four times as much light to reach the sensor as an aperture of f/2, and f/2 lets in four times as much light as f/4.

While the numbers behind the aperture can be confusing, the most important thing to remember is that each major aperture increment (f/2.8, f/4, f/5.6, and so on) represents a halving or doubling of the amount of light reaching the sensor. In other words, if you double the size of the aperture (open up by one stop, from f/5.6 to f/4, for example), you would need to halve your shutter speed in order to maintain the same overall exposure.

Canon EOS 1Ds Mark II, 16-25 mm zoom @ 25 mm, 1/250 sec, f/10, ISO 100

An aperture of f/10 helps keep the chains in focus, as well as ensuring the buildings in the background are sharp enough to be recognizable.

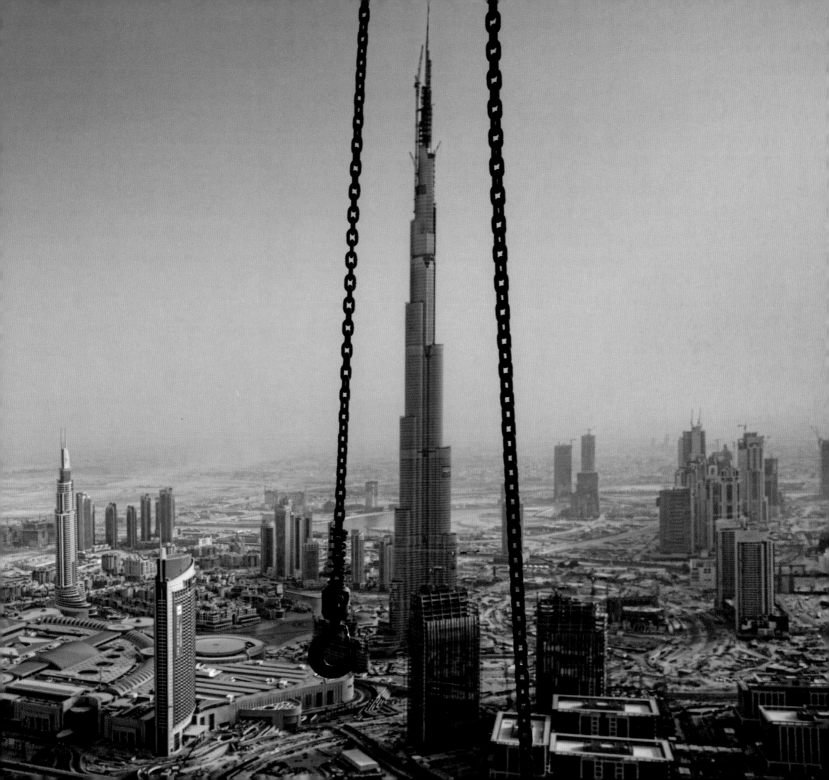

Depth of field

While the mechanical effect of varying the size of the aperture is to alter the amount of light reaching your camera's sensor, it also has another important effect—it changes the depth of field. Depth of field refers to how much of an image is in focus in relation to the point of focus. When you use a large aperture, the depth of field is shallower, while a smaller aperture will increase the depth of field. If you are shooting a landscape, for example, you might want all of the image to be in focus, from foreground to background, so a small aperture would be most appropriate. Alternatively, if you are shooting a portrait and want to isolate your subject against a blurred background, a larger aperture will provide a shallower depth of field so your subject (and little else) is in focus.

Two further factors that affect depth of field are the focal distance, and the focal length of the lens. In terms of focal distance, the farther away from the camera that you place the point of focus, the greater the depth of field. For example, if you use a 50 mm lens on a full-frame camera, and focus on the horizon (infinity) everything from 95 feet (29 m) from the camera to the horizon will be in focus using an aperture of f/2.8. However, if you focus on an object 6½ feet (2 m) from the camera, using exactly the same aperture, the depth of field will only extend from 6 feet (1.9 m) to 7 feet (2.1 m). In other words, it's easier to produce an image with a shallow depth of field when the main object of the shot is closer to the camera.

By the same token, the focal length of the lens also has an impact on depth of field; wide-angle lenses have a much larger depth of field than telephoto lenses. For example, with a focus distance of 33 feet (10 m), and an aperture of f/2.8, the depth of field will extend from 8w feet (2.6 m) to infinity using a 17 mm focal length lens on a full-frame camera, but if you switch to a 200 mm telephoto lens—keeping the same focus distance and aperture—the depth of field extends from just 32 feet (9.8 m) to 33½ feet (10.2 m).

Previewing the depth of field

When you look through a digital SLR's viewfinder, you do so at the maximum aperture of the lens you have attached to your camera. This lets as much light as possible travel through the lens, which helps when focussing, but it doesn't give you any useful feedback about the depth of field unless you are shooting at that aperture. However, most digital SLRs have a depth of field preview button that stops the lens down to the selected "taking" aperture. This lets you see the view through the aperture that will be used at the moment of image capture, so you can check the depth of field. The only problem is that smaller aperture settings let in less light, so while the preview image in the viewfinder reveals the depth of field, it will be very dark, especially at the smallest aperture setting.

Canon EOS 5D, 17-40 mm lens @ 17 mm, 1/200 sec, f/11, ISO 100

Shooting at f/11 with a wide-angle focal length maximizes the depth of field so everything in the frame is in sharp focus

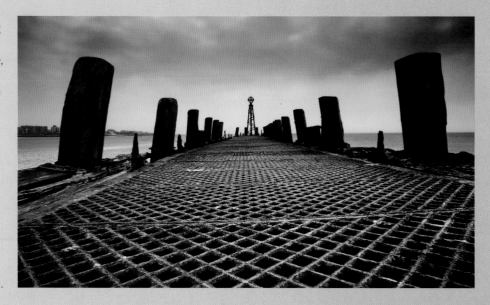

Canon EOS 5D Mk II, 85 mm lens, 1/8000 sec, f/1.2, ISO 100

Here, a telephoto lens and a very wide aperture has been used to produce a shallow depth of field where only the smallest part of the subject is in focus.

Controlling exposure: The shutter

While the mechanics of the shutter are more complicated than those of the aperture, its function is similar—it regulates the amount of light reaching your camera's sensor. All digital SLRs utilize a focal plane shutter, formed by a pair of mechanically operated blinds, or "curtains," that open and close to regulate the duration of the exposure. When you press the shutter release the first blind opens to start exposing the sensor to light, and the second blind follows to close the shutter. For very short exposures (typically faster than around 1/250 sec), the second blind starts to close before the first has finished opening, so the sensor is exposed to a fast-moving slit of light that travels across it. The faster the exposure, the narrower the slit between the two blinds.

As most digital SLRs offer a shutter speed range from 30 seconds to 1/4000 sec, or 1/8000 sec, it covers a much larger EV range than the aperture. But, more importantly for the creative photographer, while the aperture controls depth of field, the shutter controls motion. A short shutter duration has the potential to "freeze" a moving subject, with extremely short shutter speeds capable of recording moments in time that are simply not possible to see with the naked eye. At the opposite extreme, a longer shutter speed can introduce a sense of motion, either through camera movement or subject movement. Extremely long shutter speeds can go as far as transforming the subject, again producing an image that exceeds human vision. It is these creative extremes that we will look at in more detail in subsequent chapters.

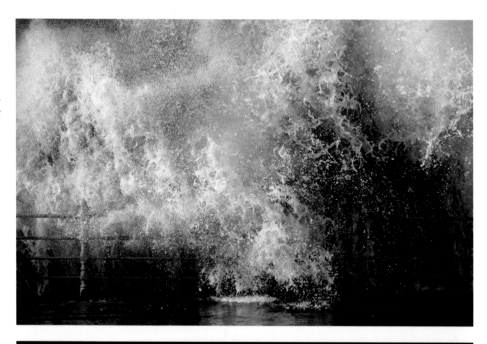

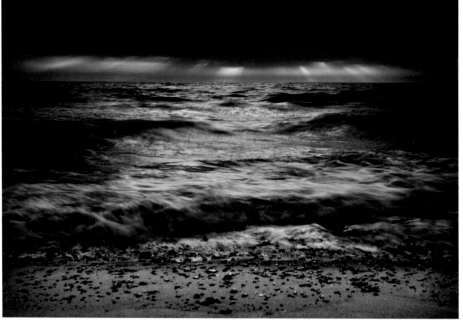

top: **Canon EOS 5D, 70-200 mm zoom @ 105 mm, 1/800 sec, f/5.6, ISO 100**

bottom: **Canon EOS 5D, 24-70 mm zoom @ 48 mm, 1/4 sec, f/8, ISO 100**

opposite: **Canon EOS 20D, 17-40 mm zoom @ 17 mm, 30 secs, f/11, ISO 100**

These three shots of the sea were taken at a variety of shutter speeds. You can see how a fast, 1/800 sec shutter speed freezes the crashing waves in the first shot (top), while a very long exposure transforms the water into a smooth "fog" (opposite). Setting an exposure of 1/4 sec (bottom) introduces blur, but the waves are still recognizable. In each case, it's the same subject, just photographed with a different shutter speed.

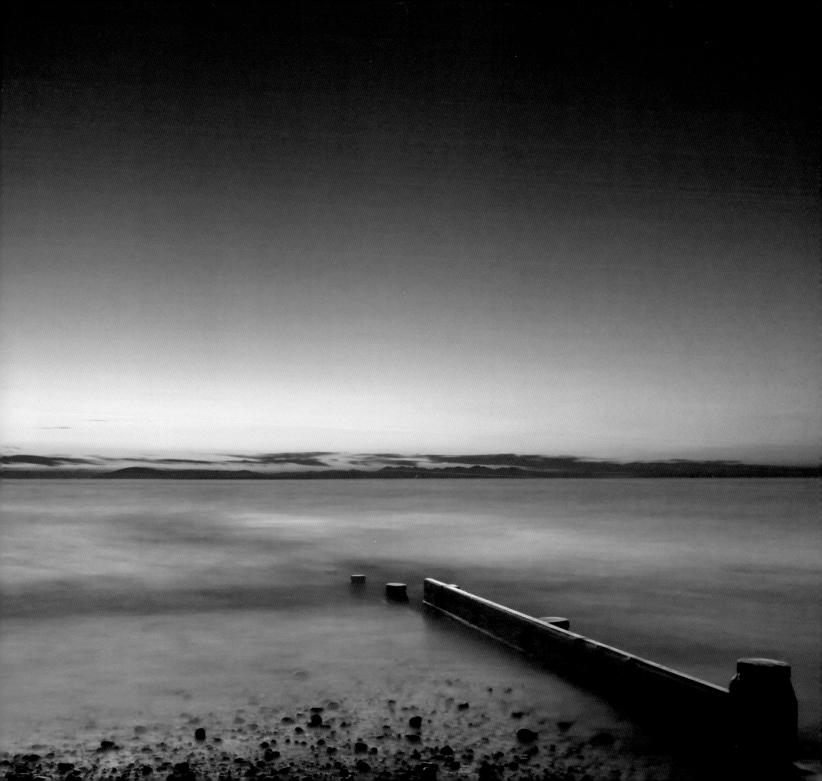

Controlling exposure: The ISO

The third exposure control in the digital photographer's exposure armory is the ISO, which effectively controls the sensitivity of the sensor to light. If you increase the ISO from 100 to 200, for example, you double its sensitivity to light, while increasing it to ISO 400 would double it again. This can be very useful if you want to use a specific aperture and shutter speed pairing or want to shoot handheld in low-light, and also gives you the flexibility to adjust your camera's ISO setting on a shot-to-shot basis.

However, there is a downside to this versatility. When you increase the sensitivity, your camera is basically "boosting" the signal from the sensor. As well as increasing the image-forming parts of this signal (the picture), the amplification also increases any non-image-forming elements, in much the same way that turning up the volume on a radio increases background static, hissing, and crackles. In a digital image, these non-image-forming elements appear as "noise," which takes two main forms: Chroma noise, which is an undesirable variance in color, and luminance noise, which is an undesirable variance in brightness. Both appear as "speckles" in the image (most noticeable in midtone areas), and the higher the ISO, the greater the amount of noise.

Smaller sensors—particularly those in point-and-shoot cameras—also produce more noise as the photosites that gather the signal are physically smaller, and collect less light to start with. This means the signal needs greater amplification from the outset, which is emphasized when you increase the ISO.

right: **Nikon D40, 18-55 mm zoom @ 35 mm, 1/125 sec, f/4.8, ISO 1600**

If you're shooting indoors and flash is prohibited, setting a high ISO is often the only solution if you want to freeze movement—and that means accepting a certain amount of noise in your images.

opposite: **Nikon D60, 18-70 mm zoom @ 18 mm, 1/4 sec, f/3.5, ISO 800**

Although unattractive in color, grain has long been associated with black and white film photography, so noise is often more readily accepted—or even enhanced — in monochrome pictures to add atmosphere.

Controlling exposure: Adding light

While there are primarily three ways that you can control an exposure with the camera, in some situations this might not be enough to let you capture the shot you want. In a low-light scene, for example, the aperture you want to use to get a large depth of field might mean the shutter speed is too slow to freeze movement, while increasing the ISO might introduce more noise than you're willing to accept.

When faced with this seemingly impossible scenario the answer is to control the amount of light in the scene so you can shoot using your desired aperture and shutter speed combination, without having to raise the ISO to an unacceptably high level. The easiest way of doing this is to turn on your camera's flash, or fit an external, hotshoe-mounted flash to replace the ambient light as the main source of illumination.

Flash isn't just useful in low-light situations, though; it can also help when you face a different problem—bright ambient light that is unevenly distributed within the frame. This is often found when photographing a shaded subject against a bright background—a backlit portrait, for example. In these situations, exposing for the brighter areas of the scene will cause other important areas to be too dark, while exposing for the shadows will lose highlight detail. Again, the solution is to add light to the scene, using a flash to "fill" the shadows and produce a more balanced result, or using it to create a more dramatic picture where the flash lighting overpowers the daylight.

Fill-flash can also be used more creatively to draw attention to a particular area of a scene—and not just for portraits, either. For example, you could use your flash to lighten the foreground in a landscape, to help balance the brightness between the sky and the ground close to the camera. We will return to using flash as a creative tool in much greater detail later on, as well as considering it as a technical solution to certain shooting problems.

left: **Canon EOS 20D, 17-40 mm zoom @ 17 mm, 1/30 sec, f/5.6, ISO 100**

Most people don't think of flash as a tool for landscape photography, but here a subtle burst of fill-flash helps add a sparkle to the ripples in the foreground.

right: **Mamiya RB67, 50 mm lens, 1/250 sec, f/8, ISO 100**

As well as providing a subtle touch of fill-in lighting, flash can also be used to overpower the ambinet light, making it the dominant source of illumination.

Exposure and metering

In addition to understanding the basic functions of the aperture, shutter, and ISO, you also need to take into account the way in which your camera evaluates the light in a particular scene to reach its exposure recommendation. Most times, in-camera metering systems will produce well-balanced images with a good range of tones, but on some occasions they will get it wrong, producing an image that is either too bright or too dark. But why does it happen, and how can you avoid it to start with?

There are two interrelated reasons that explain most exposure problems. First, the camera is measuring the light coming through the lens, so it's basing the exposure on the light reflected from a scene, rather than the light falling onto it. Second, camera meters are calibrated to work on the assumption that all scenes average out to a medium gray. So, when the amount of light being reflected from a scene is much higher (a bright scene), or much lower (a dark scene), your camera's meter can be "fooled" into getting things wrong. As a result, a dark scene can end up too bright as the camera tries to balance the tones to mid-gray, while bright scenes can appear too dark.

Exposure accuracy

To produce consistently accurate exposures you can try one of three things. The first is to use a handheld lightmeter instead of relying on your in-camera metering. This will measure the light falling onto the subject, rather than the light being reflected from it, which provides a more accurate exposure reading that isn't influenced by overly light or dark subjects.

Alternatively, you can use your in-camera meter to take an exposure reading from an 18% gray card. As its name suggests, this is nothing more than a piece of gray card, but it is designed to reflect the "average" amount of light that your camera's meter is calibrated to. So, if you meter from the card—rather than the scene as a whole—your exposure will more accurately match the level of ambient light.

Finally, most digital SLR's include a spot, or partial metering mode. Unlike a general, multi-area (matrix or evaluative) metering pattern, this lets you take an exposure reading from a very precise area of the scene. Providing you take the reading from a midtone area, the camera won't be fooled by parts of the scene that are very dark or very bright and again the exposure will be more likely to be correct.

Exposure compensation

While there are ways of producing a more accurate exposure from the outset, most photographers don't own—or want to invest in—a handheld lightmeter or gray card. This is where your camera's histogram can help. As discussed on page 12, a histogram will show you how the tones are distributed in the image, and give you an idea of any exposure problems—if the histogram is shifted to the left, the image could be underexposed, and if it's shifted to the right it could be overexposed.

Get into the habit of checking the histogram any time you think there could be an exposure issue (or with every shot if you prefer). If it shows that you've lost highlight or shadow detail, adjust the exposure using your camera's exposure compensation feature and shoot again. For images that are underexposed, use positive (+) compensation to lighten the exposure, and dial in negative (-) compensation for overexposed shots.

Handheld lightmeters can be used to measure the light falling on the scene (an "incident" light reading), which can give a more accurate exposure than the reflected reading produced by your in-camera lightmeter.

17/17¹ NIKON D5000

☑

⊡ P 1/640 F6·3 ISO200 105mm

WB AUTO 0, 0 sRGB SD⁺ AUTO

109D5000 CSC_0017.JPG FINE
12/06/2009 11:19:49 4288x2848

Your camera's histogram is a far more accurate guide to exposure than simply viewing an image on the LCD screen, so get into the habit of routinely checking it for lost, or "clipped," highlight or shadow detail. If any detail is lost, apply exposure compensation and reshoot.

Canon EOS 1Ds Mk II, 16-35 mm zoom @ 16 mm, f/2.8, 30 secs, ISO 100

Metering for a low-light scene such as this is easy with a handheld lightmeter as it measures the amount of light falling on the subject as a whole, rather than the amount of light being reflected by the subject. This avoids the risk of deep shadows or bright highlights such as the streetlamp affecting the exposure reading.

Exposure and dynamic range

Although you can use exposure compensation in most situations when your camera makes a mistake, there are times where no amount of adjustment will produce a good image. This happens when the contrast, or "dynamic range," of the original scene is larger than the dynamic range of your camera's sensor.

The term *dynamic range* refers to the luminance (brightness) ratio between the lightest and darkest areas of the scene. For example, a scene with very bright highlights and deep shadows will have a large dynamic range, while a shot taken on an overcast day—with dull highlights and soft shadows— will have a smaller dynamic range. When the term dynamic range is used to describe the abilities of a camera's sensor, it is given as a number—in either stops or EV. This figure is the brightness range that the camera's sensor can capture in a single exposure, and for most digital SLRs the dynamic range of the sensor is somewhere between 5 EV and 9 EV.

If your camera has a wider dynamic range than the scene you are photographing, it is possible to record all the detail in both the brightest and darkest areas of the image. However, when the dynamic range of a scene exceeds the dynamic range of the camera, the highlights will be blown out (recorded as pure white in the final images), or the shadows will be clipped (appear as pure black in the image), or both.

This is a difficult problem to solve as the dynamic range of a sensor cannot be changed. However, there is a technique that you can use to create an image containing a full range of tones in both the lightest and darkest areas, even when the EV range of the original scene is larger than the dynamic range of your camera's sensor. This technique is called high dynamic range (HDR) imaging, which we will explore on the following pages.

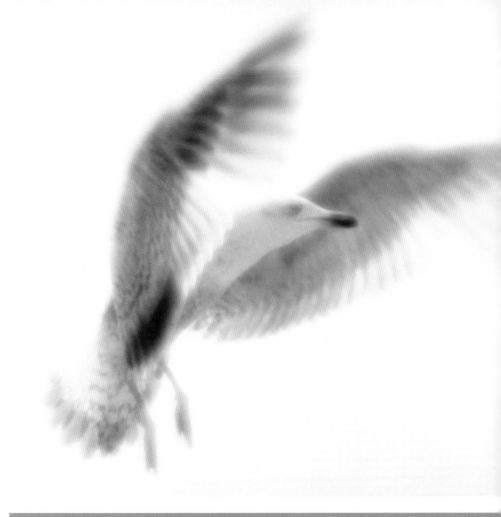

AVERAGE EXPOSURE

This sequence of images shows the problems encountered when you are faced with a scene with a high dynamic range. An "average" exposure produces a picture that lacks detail in the sky due to blown highlights, and there is also a loss of detail under the pier, which has deep, black shadows. Adjusting the exposure to get more detail in the underside of the pier makes the sky even brighter, while exposing to keep detail in the sky loses all shadow detail. It is clear that there is no single exposure that can keep detail in both the lightest and darkest areas of this picture.

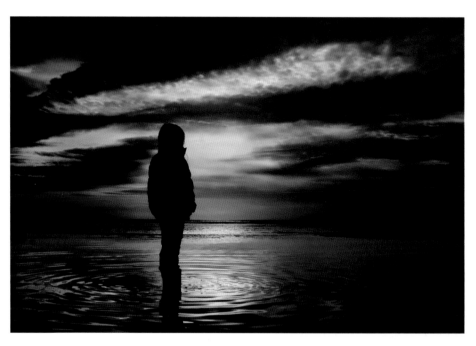

opposite: **Canon EOS 20D, 50 mm lens, 1/15 sec, f/2.2, ISO 100**

While most images benefit from an exposure that avoids losing highlight detail, some photographs can be improved — or even created — by letting the highlights "burn out," as in this image of a seagull, which has been deliberately overexposed to give a "high key" look.

above: **Canon PowerShot G9, 1/800 sec, f/8, ISO 80**

This beach silhouette has been underexposed so the subject becomes a pure black outline against the dramatic colored sky. The histogram for the shot would show dark tones bunched to the left, suggesting heavy underexposure, so don't purely rely on the histogram to guide you.

EXPOSED FOR THE SHADOWS

EXPOSED FOR THE SKY

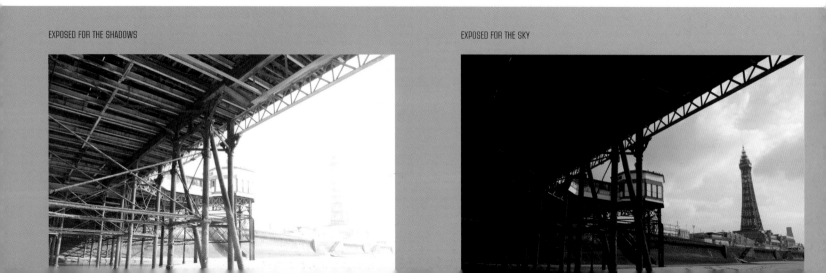

Shooting high dynamic range images

Producing an HDR image that reveals the full tonal range of a high-contrast scene is a relatively simple three-step process. First, you need to shoot a sequence of images that contain shadow detail in the brightest shot, and highlight detail in the darkest image. You then need to combine this sequence (which could contain anything from three to seven shots) into an HDR image using HDR software. Finally, you need to process, or "tonemap," the HDR image so it can be displayed on a computer monitor or printed on your inkjet printer.

Shooting your initial exposure sequence

Although most HDR programs include methods of aligning multiple exposures with one another, none is 100% reliable, so you should shoot your original sequence using a tripod.

For the best results you will need to shoot a minimum of three exposures: one at the camera's recommended exposure setting, a darker image that doesn't contain any clipped highlights, and a light image that doesn't contain any clipped shadows. There are no absolute rules on how far apart each exposure in the sequence should be, but somewhere between 1 EV and 2 EV will work well for most HDR sequences and you can do this either manually, or by using your camera's automatic bracketing. Check your camera's histogram to evaluate the exposures, and if three shots don't cover the entire dynamic range, shoot more.

When shooting your sequence, it's important that you adjust the shutter speed between frames and not the aperture. Changing the aperture will mean the images in the sequence have a varying depth of field, which will lead to artifacts in the final result.

If you are shooting a static scene, the speed at which you shoot an exposure sequence isn't an issue. However, if components within the scene are moving or are likely to move—such as clouds, foliage, people, vehicles, and so on—then the faster you shoot your sequence of images the more likely these are to be in the same place throughout the series, preventing unwanted artifacts in the final image.

Creating a 32-bit HDR image

Once you have taken your exposure sequence you need to combine the shots using an HDR program such as Photomatix Pro or FDRTools. These programs automatically merge the sequence into a 32-bit HDR image that contains the full dynamic range of the original scene. This is a relatively straightforward process that often involves little more than choosing how to align the images and how to minimize any motion artifacts. Once you have created your HDR image, you can proceed to the final, and most important stage: Tonemapping.

Tonemapping

Although a 32-bit HDR image contains the entire dynamic range of the original scene, it cannot be displayed on a computer monitor or printed as—like your camera—these are low dynamic range devices. This means the dynamic range needs to be compressed, or "tonemapped." A tonemapped image looks much like a conventional photograph, with the areas you expect to be bright retaining their bright appearance, while darker areas remain dark. The difference is that the full dynamic range of the HDR image is retained after the tonemapping process, so an HDR landscape image can contain a dramatic sky with plenty of detail *and* a full range of tones in the shadow areas.

I have used FDRTools and Photomatix Pro to produce the images shown here, both of which are very effective. FDRTools is a great choice if you are interested in producing HDR images with a more photorealistic feel, while Photomatix Pro can be used to produce pictures that are more surreal. In both cases there is plenty of control over the result, and it is generally a case of experimenting with the various settings to produce the result you are after.

This is a typical HDR image. The first shot in the sequence (right) shows the scene as it was metered by the camera, with overly dark shadows and bright highlights. To capture the full dynamic range, two further exposures were made at -2EV and +2EV. Mounting the camera on a tripod and adjusting the shutter speed, not the aperture, means that the content of each frame is identical, except for its brightness. The final HDR image (above) was constructed from these three exposures using Photomatix Pro software. Note how there is detail in all parts of the picture, from the darkest to the brightest.

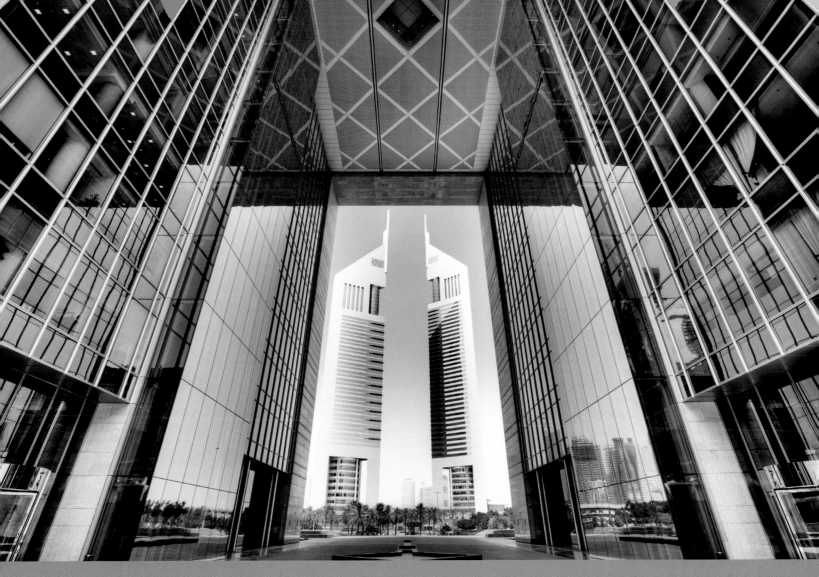

-2 EV

+2 EV

Additional notes for film users

While virtually all of the techniques we will discuss later in this book can be carried out using either a digital or film-based camera, there are three things that you will need to bear in mind if you are shooting film.

ISO

Film-based cameras are less flexible than their digital counterparts, in that you need to choose a film with a particular speed, rather than being able to vary the ISO on an image-by-image basis. However, shooting with a high ISO film will often produce esthetically better results than high ISO digital capture, simply because the grainy nature of film is more appealing than digital noise, appearing "organic" rather than "artificial."

Film and dynamic range

As mentioned previously, the dynamic range of most digital SLRs falls somewhere between 5 EV and 9 EV, but with film, the dynamic range is determined by the type of film you use. Slide film, for example, shares a similar dynamic range to a typical digital sensor, but color negative (print) film is able to record an EV range of up to around 12 EV. Black and white negative film can have an even higher dynamic range. So, when you are shooting scenes with a high dynamic range, you have a greater chance of capturing the entire contrast range in a single shot when using a film-based camera and negative film.

Reciprocity failure

While the above points are interesting, their impact on most of the topics we will be covering in subsequent chapters is minimal. Reciprocity failure, on the other hand, is something you do need to understand in more detail, especially when it comes to shooting ultra-long exposures.

A digital sensor generates a signal that is proportional to the amount of light it receives, so if the amount of light increases, the signal increases by a relative amount,

regardless of the exposure time. Under normal levels of illumination, film responds in the same way, but when the scene demands a significantly longer exposure, this proportional relationship begins to break down.

The reason for this is the light-sensitive grains in a film require a discrete number of photons to strike them before they become developable. Under normal circumstances (at relatively short exposures), sufficient photons will hit the grains in a reasonably short period of time, causing the photo-chemical reaction to take place. However, with long exposure times, the rate at which the photons strike the grains is too slow to produce the photo-chemical change. This means film effectively becomes increasingly insensitive as the light levels fall, so you need to use an even longer shutter speed than you might predict. Fortunately, most film manufacturers include a data sheet indicating how to correct your exposures to take account of this issue, but if you are in any doubt I would recommend that you shoot a range of additional (longer) exposures to make sure you get the shot you want.

Nikon F5, 28-70 mm zoom @ 35 mm, 3.2 secs, f/8, Fuji Velvia 100

As exposure times increase in low-light situations, film effectively becomes less sensitive to the light, which requires the exposure to be extended even further.

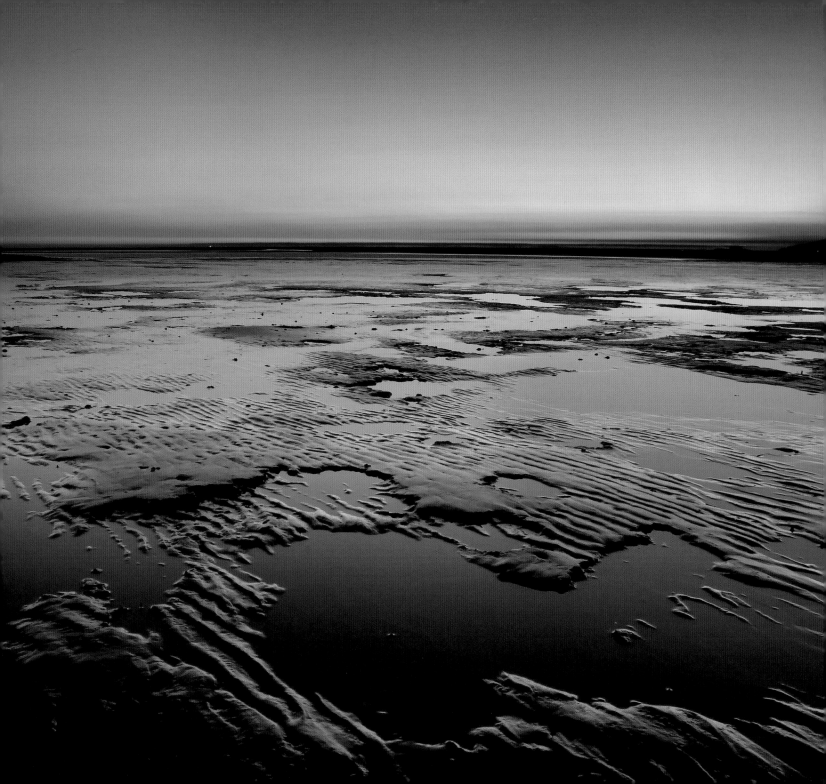

A-LONG SHUTTER SPEEDS

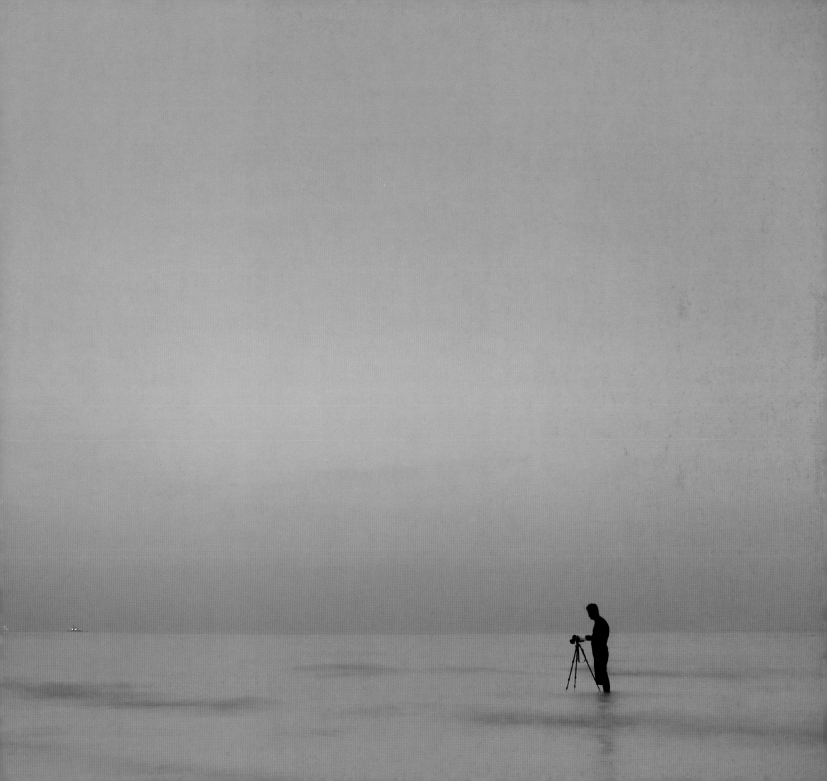

Low-light photography

Dimly lit scenes such as landscapes at twilight or just before dawn, a candle-lit room, the lights of a city at night, and so on, are inherently photogenic. As we will see in this chapter, low-light photography covers myriad subjects, from moonlit landscapes, to light trails in a bustling city. Each one can produce images with a uniquely beautiful character, but they all have one thing in common—the use of a long exposure.

A long shutter speed will let you record low-light scenes without using flash—a useful tool in some situations, but one that can easily ruin the atmosphere of low-light photographs. This means the most important tool you need is a tripod or similar support. Even if you have extremely steady hands, and an image-stabilized lens (or your camera has sensor-based stabilization), your camera will move slightly during *any* handheld exposure. With short shutter speeds this movement is negligible, and doesn't appear to affect the image, but as the length of the exposure increases, so any minor movement begins to affect the final picture. So, when you're shooting extended exposures, a tripod or some other means of support is absolutely essential if you want sharp images.

If you don't have a tripod—or don't have one with you— brace your camera against a solid object such as a wall, the ground, a fence, or similar. Providing your camera is properly supported, you can shoot your low-light images at a low ISO setting to keep images free from noise, and can use a small aperture to maximize the depth of field—useful for sweeping low-light cityscapes and landscapes.

While it may sound counter-intuitive, the shorter your extended exposure is, the more important it is to use a remote release, as well as a tripod, rather than manually activating the shutter. The reason for this is that when you press the shutter—even with your camera supported on a sturdy tripod—you run the risk of introducing vibrations

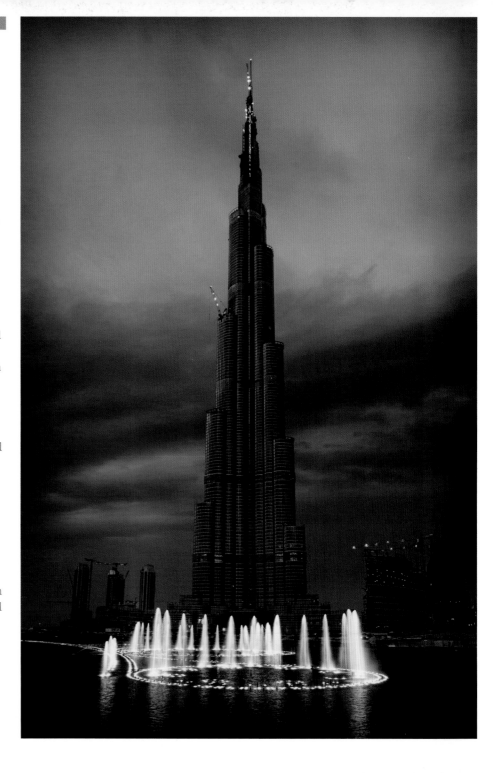

opposite: **Canon EOS 1Ds Mark II,** **16–35 mm zoom @ 16 mm, 0.4 secs,** **f/6.3, ISO 100**

Using a low ISO sensitivity will extend the exposure time required for your low-light shots, but it will also produce images that exhibit less noise than a higher ISO setting.

above: **Canon PowerShot G5, 1/8 sec,** **f/2.0, ISO 50**

Shooting in low-light situations usually means using slow shutter speeds that can introduce movement into your photographs. Using a tripod and a remote release (or your camera's self-timer) can help.

simply because you are touching it. With very long exposures the minor vibration at the start of the exposure is unlikely to compromise the final image because your camera will remain stationary for the majority of the exposure—the movement makes up only a small part of the overall exposure. However, with shorter exposures (but not *short* exposures) the movement affects a proportionally longer part of the overall exposure, so any minor vibrations can compromise the sharpness of your images. To counter this, use a cable release, remote electronic release, or, as a zero-cost alternative, your camera's self-timer. Set the timer to its maximum countdown (usually 10 or 12 seconds) and

press the shutter release to start the timer. When the camera fires, your hands won't be touching it, which will reduce the risk of photographer-induced vibrations. If your camera has one, activate the mirror lock-up facility to reduce any potential vibrations even further.

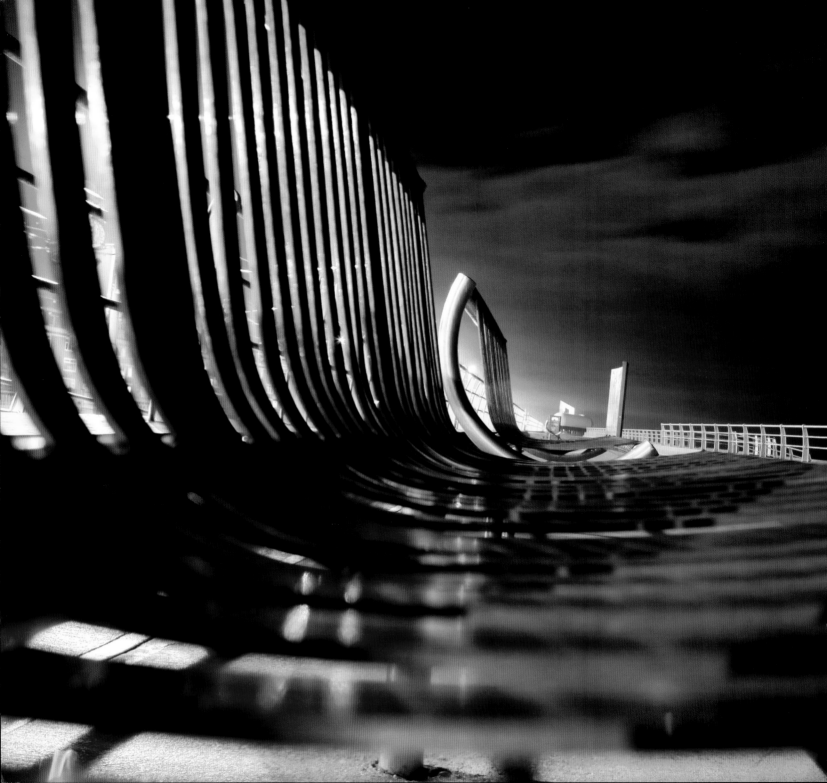

Canon EOS 20D, 17-40 mm zoom @ 17 mm, 30 secs, f/5.0, ISO 100

To avoid camera shake ruining your long exposure photographs, your camera needs to be supported. A tripod is the most common solution, but you can also use a wall, a fence, or some other improvised support. For this shot I simply placed the camera on the bench I was photographing.

Setting the shutter speed

Although using a long shutter speed is the key to low-light photography, the actual duration of the exposure is unimportant in most situations. For example, if you are photographing a landscape just after sunset, a low ISO sensitivity to minimize noise and a small aperture to give you the maximum depth of field is the best starting point. If you use Aperture Priority, the camera will set the shutter speed and—assuming you're using a tripod—it doesn't much matter if the shutter speed is 1/4 sec, 5 seconds, or even 30 seconds because it is a relatively noise-free exposure and the depth of field that matter most.

However, on other occasions, the precise duration of the exposure may be more important, especially when there's movement in the frame. For example, if you are photographing a waterfall in twilight you might want to restrict the shutter speed to a few seconds to add a suggestion of motion blur. Alternatively, you might prefer to use your camera's longest shutter speed setting to turn the water into a misty veil. In either case, setting your camera to Shutter Priority—to control the shutter speed— and setting a low ISO to minimize noise would be the ideal starting point, with the camera determining the aperture.

With most cameras, the longest exposure time you can set in Shutter Priority mode, and the longest indicated exposure your camera will provide when shooting in Aperture Priority or Manual, is 30 seconds. This is usually long enough for most low-light situations, but as we will see, there are some low-light situations that work best if you use exposures measured in minutes, or even hours, rather than seconds. For these projects, you will have to switch your camera to its Bulb mode, which will let you manually hold open the camera's shutter to make the exposure. This might mean you have to depress and hold the shutter button for the entire duration of the exposure, or you have to trigger the shutter to start the exposure and trigger it a second time to end it.

Night scenes

There's no clear cut-off between low-light photography and night photography, and both use the same basic principles—a tripod, remote release, and an ultra-long shutter speed being the key ingredients. However, night photography brings with it a number of unique challenges and creative opportunities. The primary challenges include focusing and composing in near or total darkness, and calculating the correct exposure.

In daylight, focusing your camera is a simple matter, whether you're relying on the camera's autofocus system, or focusing manually. When you are shooting at night, though, things get much more complicated. For a start, there is often insufficient light for your camera's autofocus system to work, so you'll have to focus the lens manually. Yet even this isn't straightforward as the low light levels often mean you simply can't see any detail in the scene through your viewfinder, so how exactly are you supposed to focus when you can't see what you want to photograph?

The answer is to estimate the distance from your camera to the main subject in the scene and set the focus manually. If you're shooting a landscape this is fairly easy—as the natural focus point is the horizon, all you need to do is set the lens to infinity focus. If the main subject is closer to the camera, setting an accurate focus point is much more difficult, especially if you can't see the subject to guess the distance to start with. In these cases, a powerful flashlight can be a great help as it will let you add temporary light to the scene to help gauge the distance.

Focusing is not the only issue you will have when it comes to photographing night scenes. When you can't see the scene you're photographing, composing a shot can be just as difficult, if not impossible. However, as your camera will be on a tripod, the easiest way to get around this is to shoot some test frames at the highest ISO setting using the widest aperture your lens offers. This will give the shortest possible

exposure time, enabling you to review your composition on the camera's LCD screen and adjust the composition as necessary. Once you have composed the image you can set the aperture and ISO you want to use for the final shot and make your extended exposure.

Calculating the correct exposure

In low-light conditions, a camera's metering system is less reliable than it will be in daylight, and at night it can prove even more difficult. As discussed earlier, this is because it assumes that the scene it is photographing is largely comprised of midtones. At night, when there is little or no light, this is clearly not the case and the most likely outcome if you rely solely on your in-camera lightmeter is that all of your night shots will come out too light. The suggested meter reading will provide a starting point, but applying negative exposure compensation (-1 to -2) to an automatic exposure reading is a good start point.

above: Nikon D90, 18-105 mm zoom @ 20 mm, 4 secs, f/11, ISO 100

opposite: Canon EOS 1D Mk III, 50 mm lens, 3.2 secs, f/8, ISO 100

Whether it's the desolation of empty streets, or the natural and manmade colors of night, taking your camera out when most people are sleeping is the perfect opportunity to record scenes that are both familiar, yet somehow remote from our everyday lives.

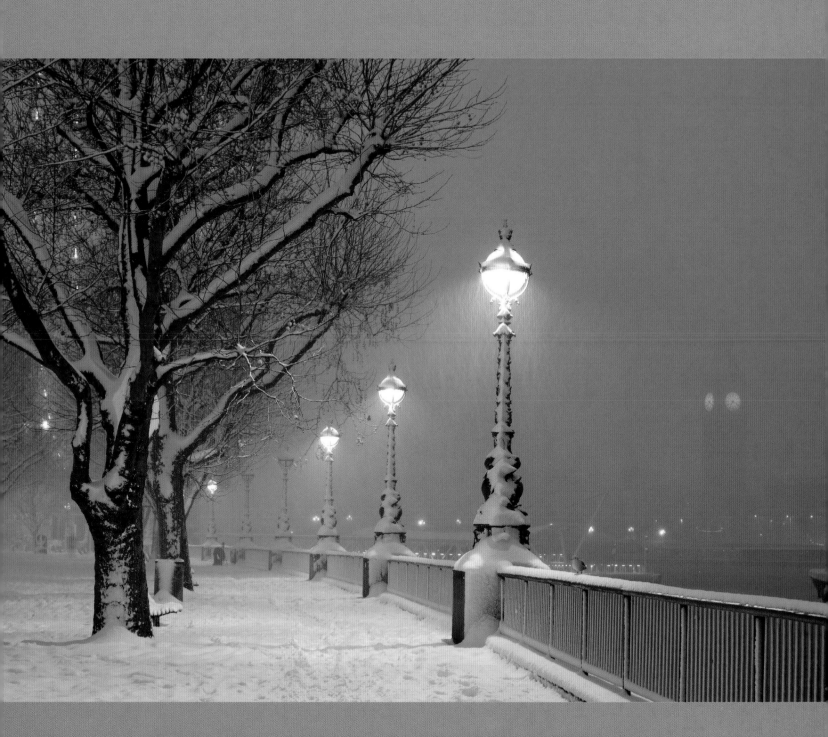

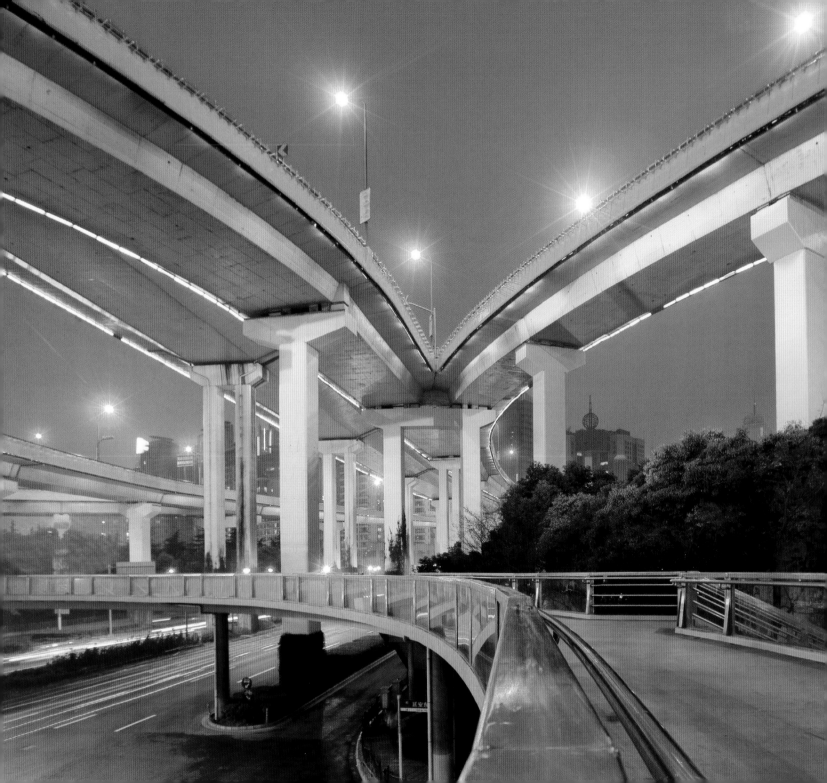

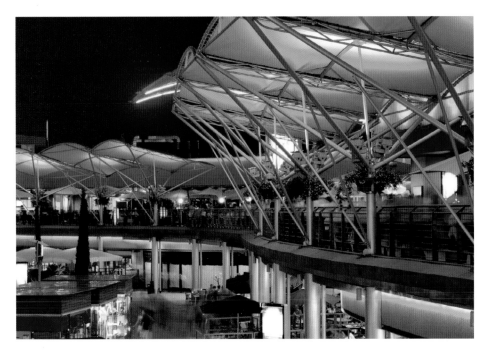

During the hours of daylight, this highway near Shanghai, China (opposite), or the Madrid shopping center would have much less appeal, but at night they are both transformed by the unusual artificial lighting.

stops you need to adjust it by. In this example, let's say the shutter speed falls to 30 seconds at ISO 800. We know that the difference between ISO 800 and ISO 100 is three stops, so the correct exposure time at ISO 100 would be three stops more than it is at ISO 800. Therefore, if the exposure at ISO 800 is 30 seconds, it would be 60 seconds at ISO 400 (one stop), ISO 200 would require a 120 second exposure (two stops), and ISO 100 would need you to have the shutter open for 240 seconds, or 4 minutes (three stops). Having determined the exposure time you can set your camera to Bulb mode, the ISO to 100, and make the exposure, in this example for 4 minutes.

This is straightforward enough if the ISO alone gets you within the camera's 30 second limit, but when you're shooting at night this isn't always guaranteed. Even at the highest ISO setting your chosen aperture might require a longer exposure, in which case you need to adjust both the ISO *and* aperture, noting how many stops you adjust them in total. Following the previous example, let's say you wanted to shoot a scene at f/22, at ISO 100, and your digital SLR has a maximum ISO setting of 1600. If you find you get to ISO 1600 and the shutter speed is still more than 30 seconds, you need to start opening up the aperture. In this example, let's say that the camera indicates a 30 second exposure is possible at f/11 and ISO 1600. In total, you have increased the ISO by four stops (ISO 100-1600), and opened up the aperture by two stops (f/22–f/11)—a total of six stops. This means that the shutter speed at f/22 and ISO 1600 is six stops more than 30 seconds. You can now determine the exposure time by doubling the exposure for each stop adjustment, which gives a final exposure time of 32 minutes.

At very long exposures like this, photography isn't an exact science, so experiment with extended and reduced exposure times. You should bear in mind that significant adjustments will be needed to have a noticeable effect—with the 32 minute exposure used in the example above you would need to reduce the exposure to 24 minutes to make the image just half a stop darker, for example, or extend it to 48 minutes to lighten it by half a stop.

However, if your camera's maximum selectable shutter speed is 30 seconds, and a longer shutter speed is indicated, this can make things difficult. If this happens, you have two options. The simpler of the two is to experiment with the shutter speed in Bulb mode using nothing more than trial and error. Extend the exposure from 30 seconds, taking additional exposures and doubling the exposure time with each shot (effectively increasing the exposure by one stop with each shot). Using the histogram on your camera's display as a guide you will be able to get to the correct exposure time, although this will take time.

The alternative to this trial-and-error approach is to calculate the correct exposure time, although this requires a much better understanding of "stops" in terms of ISO, aperture, and shutter speed. Say, for example, that you want to take a shot at f/8 and ISO 100, but your camera indicates the exposure is beyond 30 seconds. Having set your desired aperture, increase the ISO until the shutter speed falls within the camera meter's range, making a note of how many ISO

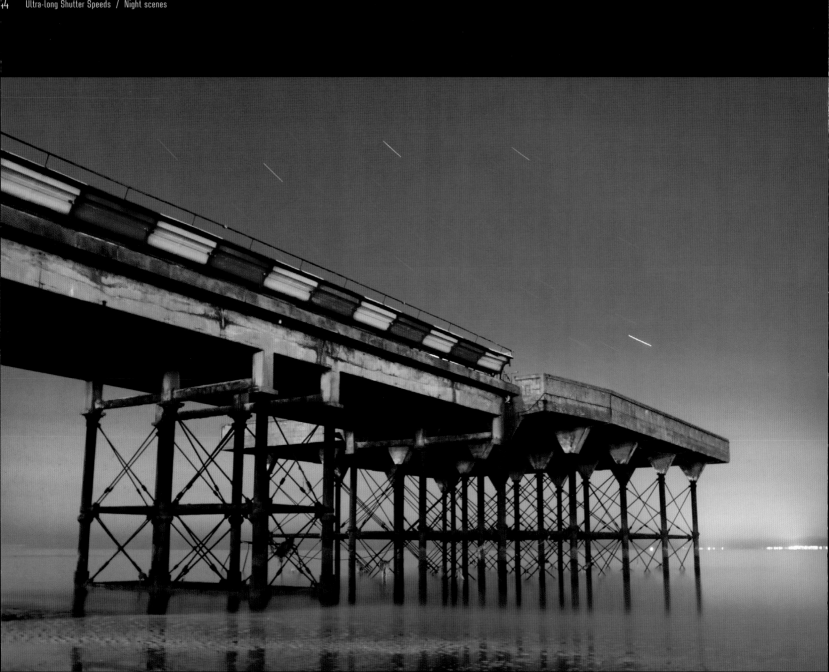

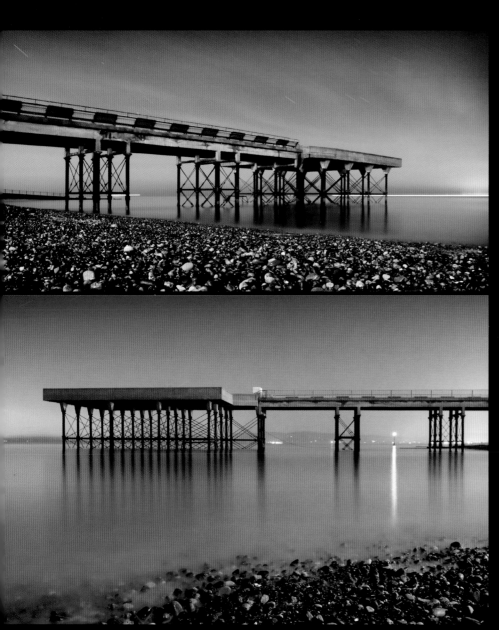

THE COLOR OF DARKNESS

At night, a scene can be so dark that it is impossible to tell what color anything should be. Often you don't need to worry about this too much—assuming there will almost certainly be something in the photographed scene that is fairly neutral in color, all you have to do is take the image and then correct the colors post-capture. You can do this by altering the white balance of a Raw image when you process it, or by making color and hue adjustments to a JPEG file.

Alternatively, you can view night photography as an opportunity to be more creative. For example, if you are photographing a landscape at night, editing the image so that the sky ends up a deep shade of blue will probably produce an image with a greater sense of photorealism, even though the sky looked black at the time. Alternatively, by altering the white balance in a more creative way, you can produce a range of different interpretations that you may find more appealing, as the examples shown here demonstrate: The subject is the same, but the color processing has produced three unique results, none of which can be said to be "wrong."

The simple rule at night is that no one knows what the "right" color is, so you have a free hand to create the most striking image, rather than a technically correct one.

clockwise from left:

Canon EOS 20D, 17-40 mm zoom @ 22 mm, 8 mins, f/5.6, ISO 100

Canon EOS 20D, 17-40 mm zoom @ 17 mm, 6 mins, f/5.6, ISO 100

Canon EOS 20D, 17-40 mm zoom @ 27 mm, 8 mins, f/5.6, ISO 100

City lights

The technical considerations that you need to bear in mind when shooting city lights are broadly similar to the things you need to pay attention to when shooting in low light or at night, but in many ways these shots are much easier to take, not least because you can clearly see the scene you are photographing. However, you do need to be aware that evaluating the exposure of such scenes—and other night shots that contain bright light sources—can often be difficult because of the extreme high contrast.

Evaluating the exposure

We've already seen how to use the histogram to evaluate an exposure and avoid clipped highlights, but when you are photographing city lights some overexposure is often inevitable and can also be desirable. This is because the lights are a lot brighter than their surroundings, so if you adjust your exposure to try to prevent them from being overexposed, the rest of the image will often be too dark.

The extent to which you need to overexpose such shots varies, and if you are unsure as to whether any overexposure is necessary—or how much to add—I would suggest you shoot a series of bracketed exposures. For example, if the metered exposure is 10 seconds at f/8, shoot two more frames: one at 5 seconds (one stop underexposed) and one at 20 seconds (one stop overexposed). That way you will be able to evaluate the images and decide which one you think works best.

One of the main problems with overexposing in this way is that the various light sources can end up looking like shapeless patches of light, and the final image can give the impression that you simply got the exposure wrong. One technique that can help with this problem is to add a subtle starburst effect (see page 49), where rays of light appear to fan out around each light source. This is very easy to do in-camera, and can create a more attractive result.

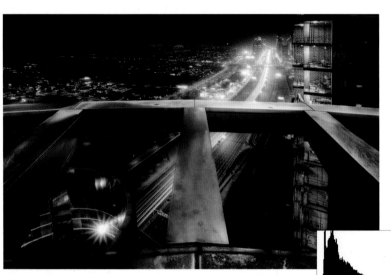

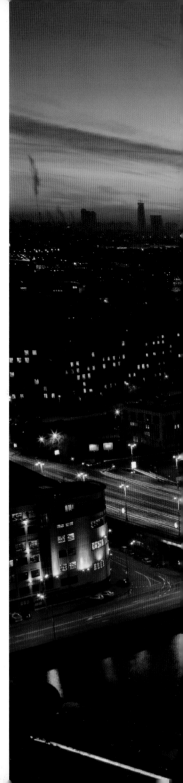

left: **Canon EOS 1Ds Mark II, 16-35 mm zoom @ 20 mm, 20 secs, f/16, ISO 100**

Although much of the histogram is shifted to the left with this shot (representing the large areas of dark tones), the short spike against the right end of the graph indicates that a small amount of data within the scene has been overexposed. However, although technically the highlights are "burned out" they don't spoil the picture because people accept that pinpoints of light will be bright in a scene like this.

right: **Canon EOS 5D Mk II, 24-105 mm zoom @ 28 mm, 13 secs, f/20, ISO 100**

Just after sunset or before sunrise the natural colors in the sky can reflect the colors of artificial city lights. In this view of Moscow the deep blue of the sky enhances the coolness of the water and the shadows, while the orange glow echoes the street and vehicle lights.

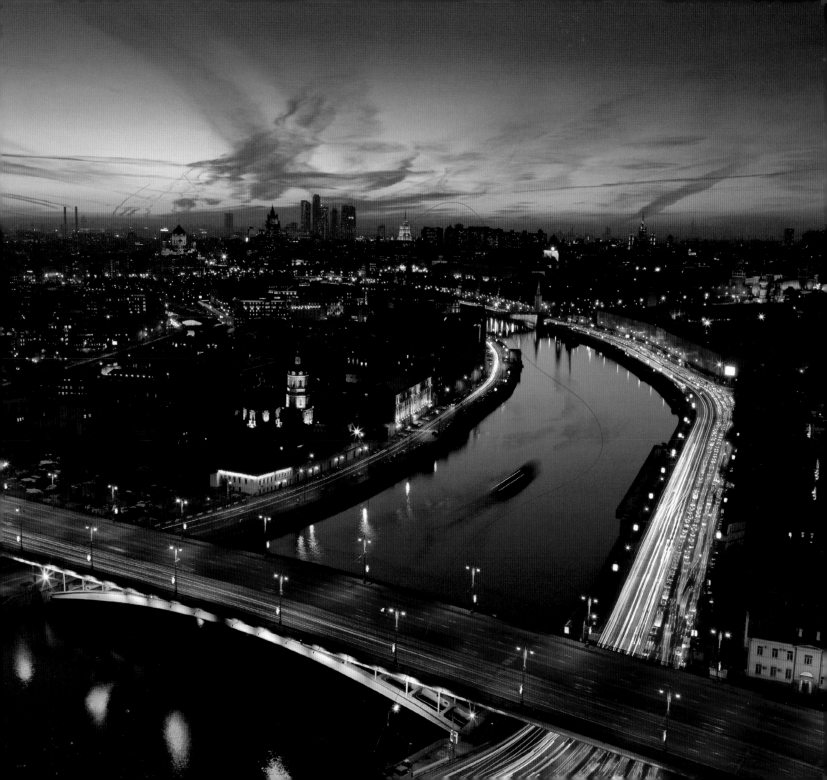

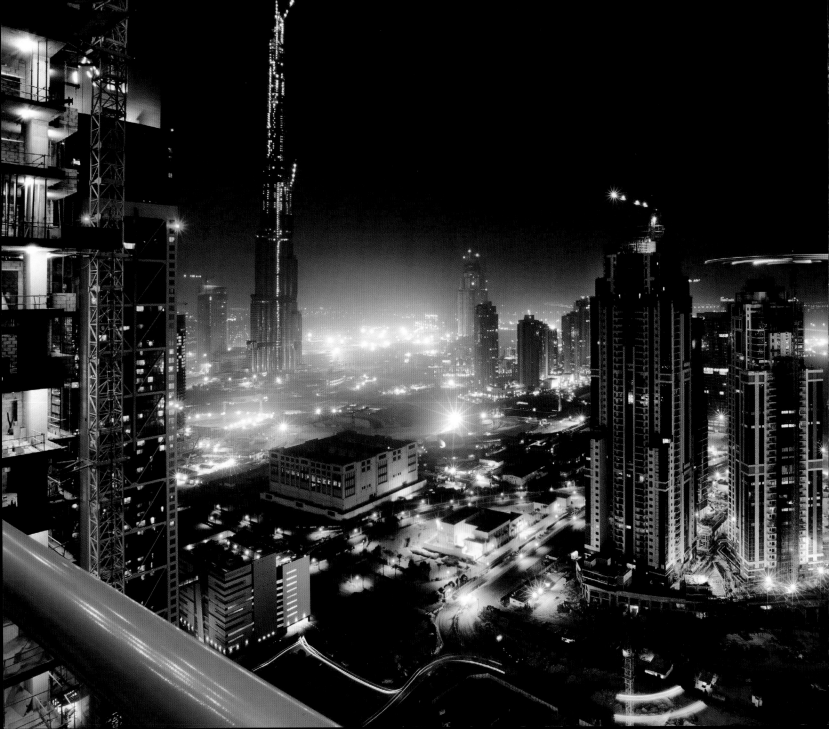

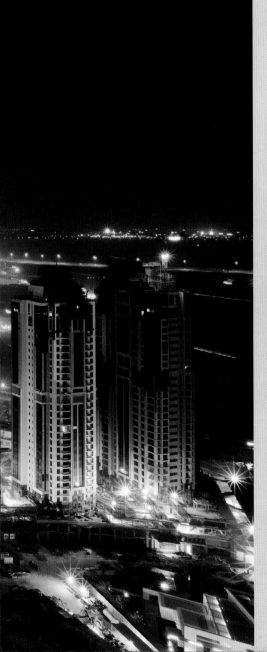

Canon 1Ds Mark II, 16-35 mm zoom
@ 16 mm, 30 secs, f/16, ISO 100

As with the previous image, the blown
highlights and blocked up shadows enhance
the atmosphere of this night shot. A careful
choice over the exposure has also created
some interesting details as outlined below.

OPTICAL STARBURST

Although you can buy a starburst filter, the easiest (and
cheapest) way of creating these interesting highlight shapes
is to shoot at a small aperture (f/16 or smaller). The small
aperture causes the light to flare at the point at which the iris
blades in the lens meet, creating a distinctive "star" effect
around point sources of light. Usually, the number of "rays"
formed for each star is equal to double the number of aperture
blades in the lens, so if an aperture has six blades, there will be
12 rays. This technique doesn't work with lenses that have
rounded aperture blades, or when the difference in luminosity
between the light source and the background is small, but it is
very effective with manmade lights in night-time cityscapes.

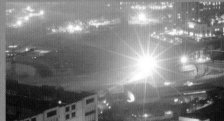

LIGHT TRAILS

As well as setting the aperture to produce starbursts, you can
use the shutter speed to add creativity to your nocturnal city
shots, in this instance by shooting with a slow shutter speed so
you record light trails left by moving elements such as cars and
other vehicles. Shutter speeds of several seconds work really
well, and long exposures such as this are a natural pairing to
the small aperture settings required for starburst effects. For
this shot, a 30 second exposure has not only recorded the
light trails from the vehicles in the city streets, but also the
movement of a rooftop crane. Selecting a slow ISO of 100
has helped maximize the shutter speed, while simultaneously
minimizing the digital noise that is often associated with
low-light photography.

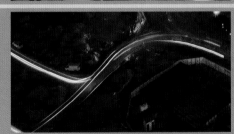

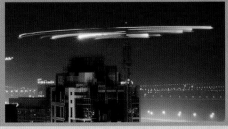

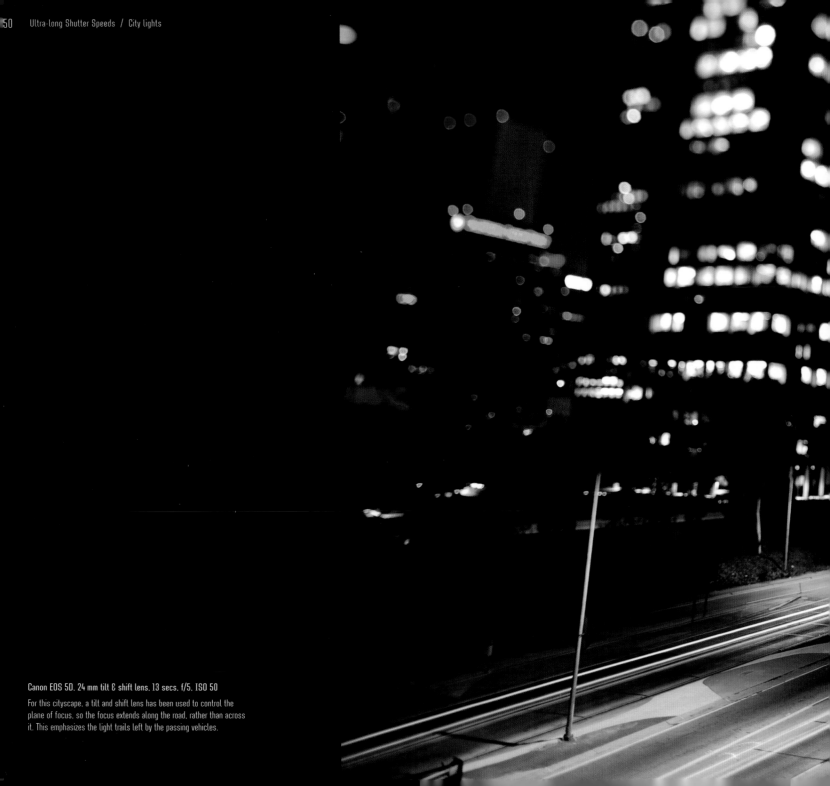

Canon EOS 5D, 24 mm tilt & shift lens, 13 secs, f/5, ISO 50

For this cityscape, a tilt and shift lens has been used to control the plane of focus, so the focus extends along the road, rather than across it. This emphasizes the light trails left by the passing vehicles.

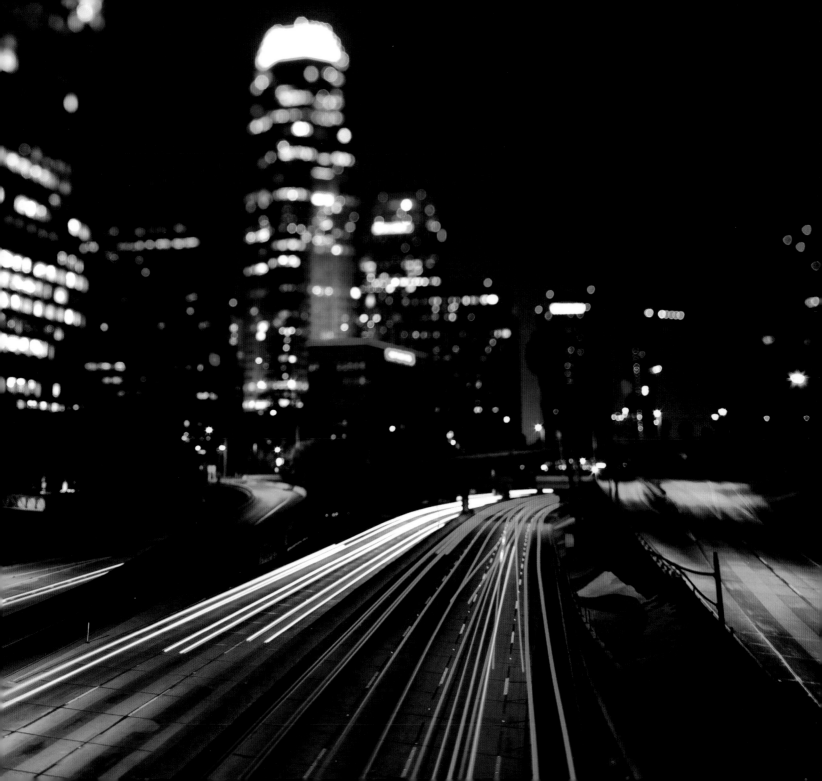

Star trails

One of the most fascinating aspects of night photography is star trails, in which the stars appear to rotate in the night sky. This motion is visible in both the northern and southern hemispheres, but it's much easier to compose a shot in the northern hemisphere because the stars rotate around Polaris—the North Star. This means you can position Polaris in the frame, knowing that this is the point around which all other stars will appear to rotate.

However, in the absence of any foreground detail, star trails will show up as little more than curved white lines against a dark background (hardly an inspiring photograph), so it's important to consider what else will appear in the frame. The star trail photographs that work best are the ones that contextualize the movement, either with an illuminated foreground, or a silhouette such as a tree or a building against the night sky.

Determining exposure

There are two things you need to consider when determining the correct exposure for a star trail shot; how bright the star trails should be, and how bright the remainder of the image should be. The first is controlled by the aperture and ISO, while the second is determined by the aperture, ISO, and shutter speed. The reason for this is that allowing more light to reach the sensor by increasing the aperture and/or increasing the ISO sensitivity will simply make the stars appear brighter—it will not affect the distance they move across the frame during the exposure. To control the length of the trails, you need to change the shutter speed; the stars will move a greater distance across the sky the longer the exposure time. The light within the remainder of the scene—the foreground, the sky, and so on—will be affected by all three exposure controls.

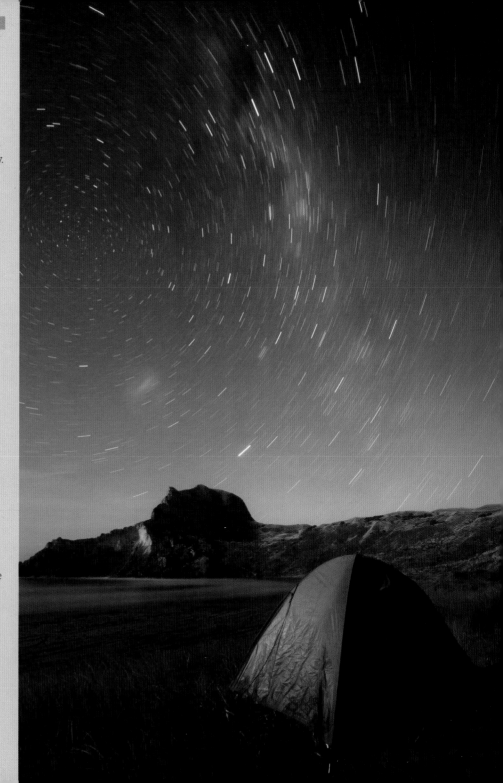

right: **Canon EOS 5D, 16-35 mm @ 16 mm, 8 mins, f/3.5, ISO 400**

A single, 8 minute exposure taken in the northern hemisphere. The camera was aimed in the direction of Polaris, with the other stars appearing to trail around it.

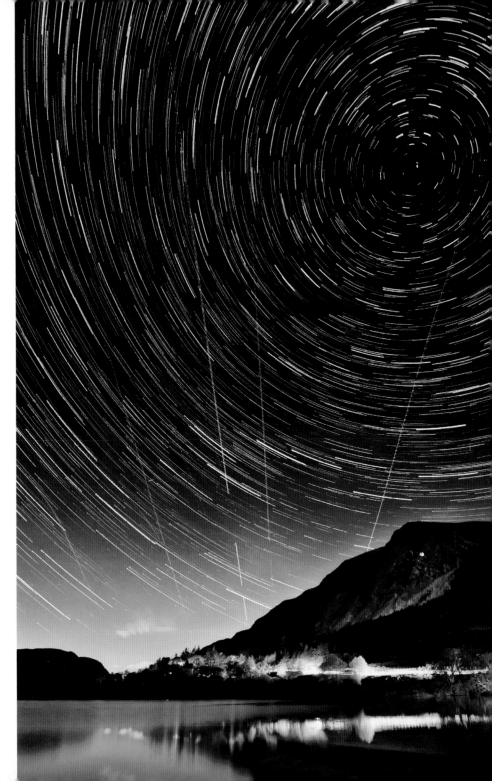

Shooting single exposures

Every scene is different but, generally speaking, a good
starting point for shooting star trails is an aperture of f/8
as this will typically deliver the best image quality from
your lens and provide a depth of field that will be sufficient
to cover both the stars and foreground, so both appear
sharp. Wider apertures can be used when you want to
reduce the exposure time, but because of the reduced depth
of field this is best done when all of the elements in the
scene are at the same focusing distance—"infinity" in the
case of stars. Regardless of the aperture, set a relatively low
ISO to minimize noise. Then calculate your exposure as you
would for a normal night scene (see page 58), bearing in
mind that the longer the exposure, the longer your star
trails will be.

One problem you may encounter when shooting star trails
with a single exposure is that the longer the exposure, the
brighter the scene as a whole will appear. If you're shooting
in a location that has minimal light pollution this isn't an
issue, as starlight will probably be the only visible light in
the scene, but with most locations you will find that the
extended exposure will result in an image where the
foreground elements and/or the sky become overexposed.

A second problem is that the longer the exposure, the
noisier the image will become—not because of the ISO
setting, but because extremely long exposures will also
increase the digital noise in an image. Fortunately, there is
an answer for both of these problems: Exposure stacking.

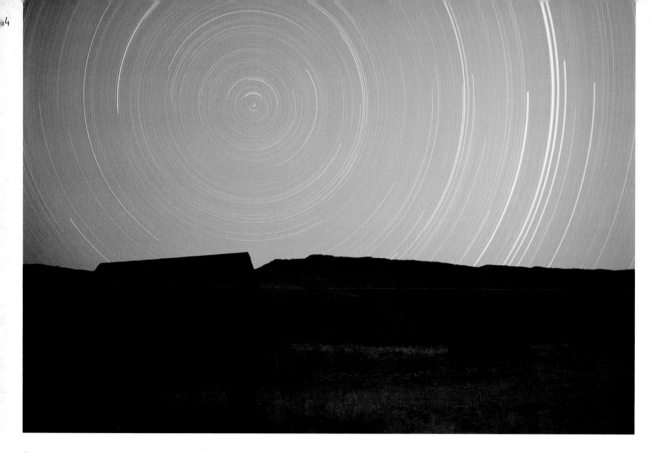

Exposure stacking

Put simply, a series of short exposures can be used to capture the same degree of movement as a single, longer exposure. For example, instead of shooting a one hour exposure, you could shoot 60 one minute exposures. The total exposure time will be the same, and 60 shorter exposures would capture the same movement of the stars. However, the ambient light would have much less of an effect on each individual image, meaning the contrast between the trails and the rest of the scene will be higher. Not only that, but as the individual exposures are much shorter they will contain less noise, allowing you to shoot at a higher ISO setting.

The easiest way to shoot a sequence of images for stacking is to use a timer that you can set to take a sequence of images lasting a specific length of time. If you don't have one of these (and most of us don't) you need to make sure

that you trigger each exposure as soon as the previous one finishes, otherwise your star trails will be fragmented—although you could use this for creative effect.

Once you have shot your sequence of images you need to combine—or "stack"—them in an image-editing program. Start with the first shot in the sequence, and add each subsequent exposure as a new layer. Change the blending mode of each additional layer to Lighten; as you do this, the length of the star trail in the image will appear to increase, without changing the brightness of the sky. Continue adding images until you've stacked your entire sequence.

A further advantage of using this method over the single-shot technique is that you can shoot additional exposures, optimized for the foreground and the sky. These elements can then be blended with the stacked star trails to create the finished picture.

left: Canon EOS 3, 35 mm lens, 8 hours, f/22, Fuji Reala 100

Shooting in an area where there is no light pollution is essential if you want maximum clarity, as in this ultra-long exposure that lasted a whole night, made on slow, ISO 100, 35 mm film.

above: Canon EOS 1D Mk III, 16-35 mm zoom @ 16 mm, 30 secs, f/2.8, ISO 1000

right: Canon EOS 1D Mk III, 16-35 mm zoom @ 16 mm, 40 exposures, 30 secs, f/2.8, ISO 1000

In the single exposure (above), a 30 second exposure isn't long enough to create star trails. However, making 40 consecutive exposures, each for the same duration, creates a total exposure time of 20 minutes and a far more striking image. Merging the images later also gives you the opportunity to expose the foreground separately, so you can combine the multiple star shots to create the trails, and then "drop in" a well-lit ground—in this shot a tonemapped HDR image.

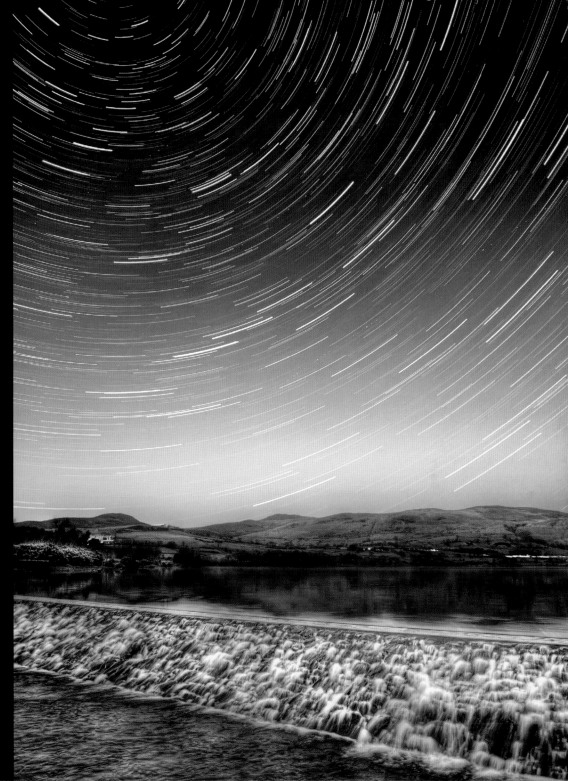

The moon

Of all the celestial objects you can photograph, the moon is one of the most interesting, not least because it's sufficiently large (and close) to be photographed in its own right. But it's also a difficult subject to photograph, as it often ends up looking disappointingly small, even if you use a telephoto lens. To fill the frame with the moon requires a focal length of at least 1200 mm, and while these extreme lenses are available, they are very expensive.

A cheaper alternative is to attach your camera to a telescope. These can range in price from several hundred dollars up to several thousand, but many will allow you to attach a camera via a dedicated mount. From a practical point of view this is the equivalent to shooting with a very long lens. As such, the main consideration is to make sure that you keep the camera, tripod, and telescope as still as possible during the exposure—even the most minor movement will compromise image sharpness.

Choosing an exposure

Whether you shoot the moon through a telescope, or with a long lens, one thing you'll soon realize is it's a lot brighter than you might expect. A full moon has an EV of around 15—equivalent to a scene in full or moderately hazy sunlight. If you are filling the frame with the moon you just need to select an appropriate exposure as you would for a shot in daylight, but if you want to include anything else in your shot you will have a problem, especially if you are photographing the moon at dusk or at night.

The problem in low-light conditions is the short exposure required for the moon (EV 15) will mean everything else in the scene (which could be anything from EV 0 to EV 9) will come out extremely dark, or just plain black. In these situations, setting the exposure to capture the detail in the scene as a whole is the best option, especially when the moon only occupies a small portion of the frame.

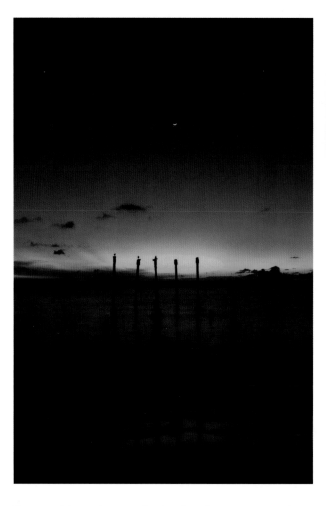

However, it's worth remembering that the moon moves in the sky. For reasonably short exposures of a few seconds this movement is unlikely to be apparent, but if you extend the exposure to several minutes you will introduce some degree of motion blur. To avoid this, consider making two exposures and merging them in your image-editing program. Make one exposure to record the night-time scene as a whole, and a second exposure to record the detail in the moon.

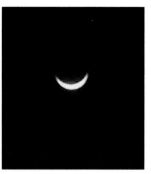

left: **Nikon D2X, Nikon 17-55 mm zoom @ 22 mm, 9.2 secs, f/16, ISO 100**

At night, when the moon is a small part of an image, it will prove impossible to record all the detail in the dark foreground and the bright moon in a single exposure. In these situations, either let the moon "burn out" to white, or shoot two separate exposures and composite them in your image-editing program. Here, one exposure was made and the small, crescent moon was allowed to come out as pure white as the detail above shows.

opposite: **Nikon D2X & Meade ETX 1250 mm telescope, 1/125 sec, f/13.8, ISO 400**

The moon is a lot brighter than you might expect, possessing an EV of around 15. This means exposure times can be surprisingly short when it fills the frame, as in this image, which was captured through a telescope.

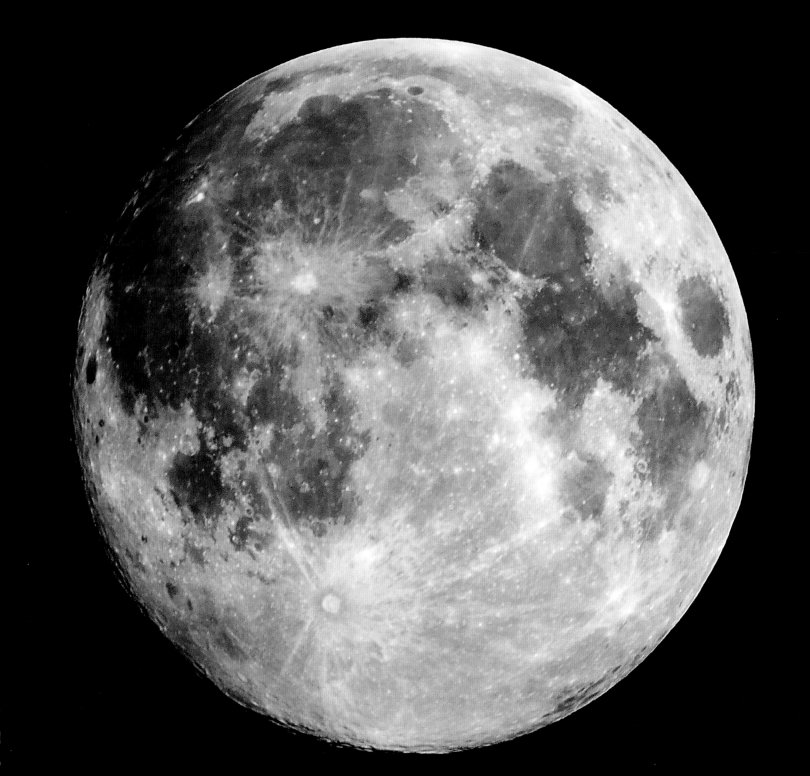

Fireworks

While most of the topics we have discussed in this chapter present some unique technical challenges, in one important respect they are no different from the vast majority of photographic subjects. In each case you are photographing a pre-existing scene, which means you can compose the shot, judge and correct the exposure, and reshoot if necessary. Photographing fireworks, on the other hand, is a radically different exercise because you need to trip the shutter *before* the subject (the explosion of color) has appeared, and each shot will be different to the last—there's no opportunity to reshoot if things don't go to plan.

Setting up

For most low-light and night scenes you can take your time and alter your shooting position if you need to recompose a shot. However, when shooting fireworks displays it is best to select a vantage point before the display starts, so arrive before dark, check out the area, and decide if you want to include any static elements—such as buildings—in your images. When you shoot the display, these elements will probably be rendered as silhouettes, so look for structures with relatively identifiable shapes. Turning up early also means you can find a position that will be unobstructed by other people. It can be difficult to move around once the display starts, and as fireworks displays tend to be quite short, trying to find an alternative vantage point while the event is happening will waste time that could be spent shooting. It's far better to find the right spot early on.

Similarly, changing lenses can be a time-consuming process that will mean you miss some of the action, so select a lens that will be appropriate to your distance from the display, and its expected size, before it starts. A zoom lens definitely offers the greatest flexibility, and if you're relatively close to the action, a standard zoom covering a focal length range of 18-70 mm (or thereabouts) is a good choice. If you're farther away you might need to use a telephoto zoom, such as a 70-200 mm zoom, for example.

below: Canon 1Ds Mk II, 24-70 mm zoom @ 38 mm, 1.4 secs, f/16, ISO 100

opposite: Canon EOS 20D, 17-40 mm zoom @ 17 mm, 2 secs, f/16, ISO 100

A great starting point for fireworks photography is an aperture of f/16 and ISO 100. Using your camera in Bulb mode, open the shutter for 1/2 sec to 10 seconds, depending on the number of explosions you want to record. Here, no more than 2 seconds was needed to capture these colorful bursts.

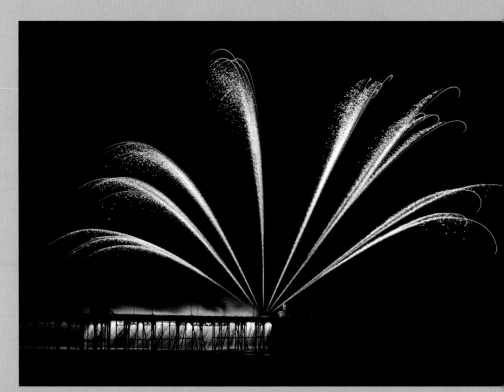

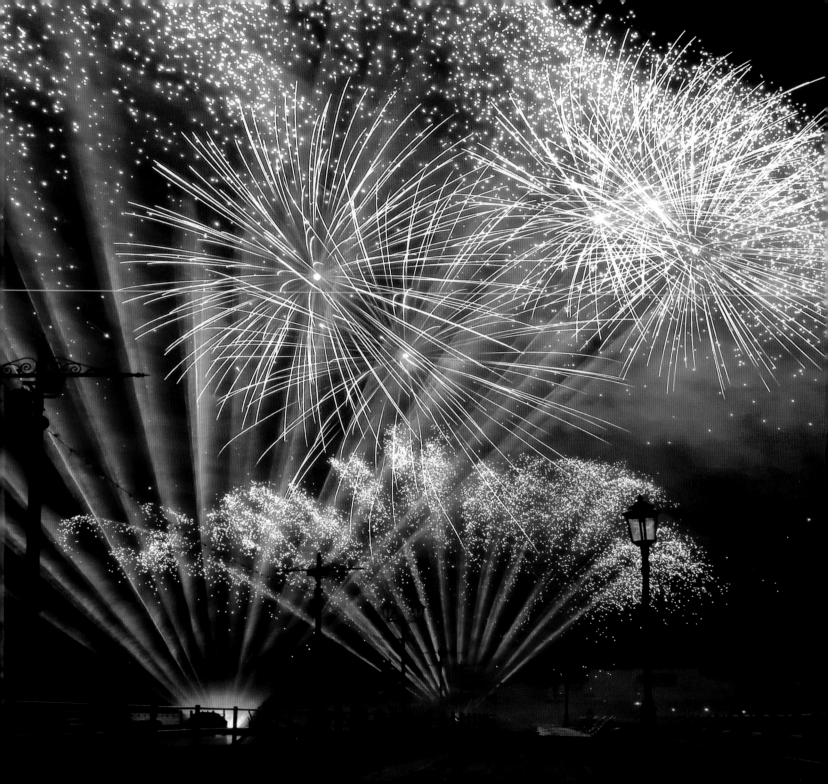

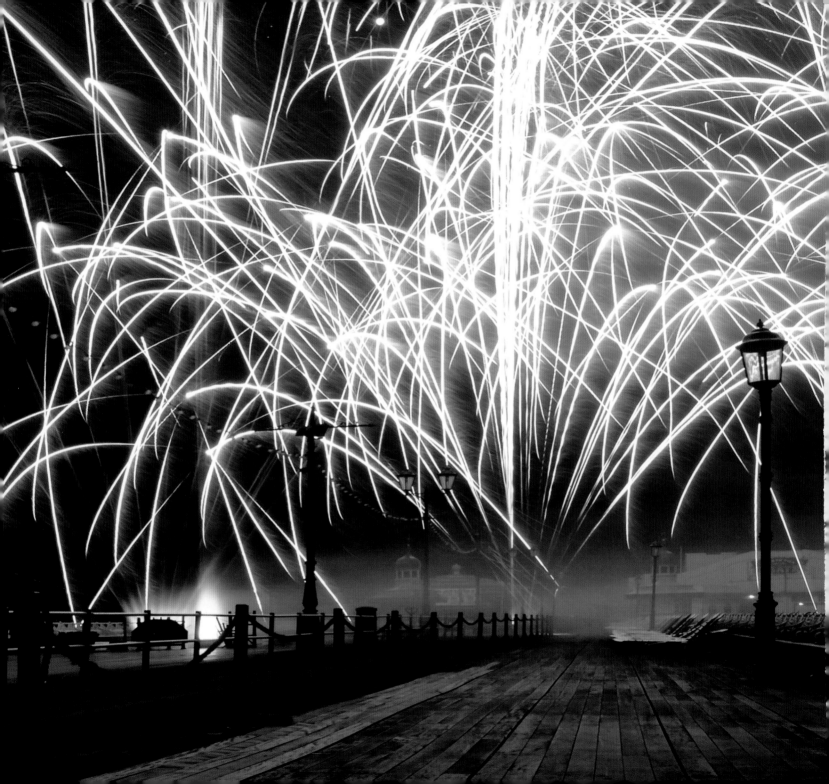

Technical considerations

Once you're in place, set your camera so you aren't fumbling around in the dark later. A good starting point is to set your camera to ISO 100, with an aperture between f/11 and f/22. As a general rule, f/16 will provide a good balance between the movement of the various light sources in the image, without overexposing any of the light trails too drastically.

In terms of shutter speed, using Bulb mode in conjunction with a remote release will give you the greatest control over exactly what gets included in each shot. Exposure times of between $1/2$ sec and 10 seconds are generally sufficient—any longer and you risk overexposure from the ambient light, any shorter and the fireworks will be tiny trails rather than full-blown explosions.

An alternative method for recording multiple fireworks—and avoiding overexposure—is to cover your camera's lens between "explosions," using a lens cap or something similarly light-tight. Start the exposure by triggering the shutter in Bulb mode, then cover the lens immediately after the first firework (but do not close the shutter). To record a second explosion, uncover the lens when you anticipate it's being launched, then cover it again once the light has faded. Repeat the process to capture additional fireworks. Because your lens is covered between the bursts, the ambient light won't affect the image as much as it would if you just made a single long exposure, so you shouldn't suffer from overexposed images.

When you've finished recording as many fireworks as you want, close the shutter and repeat the process for your next shot. Remember: you can check the exposure of your first few shots using your camera's LCD screen and histogram and adjust the aperture if necessary, but fireworks displays don't last long so you need to think and act quickly.

left Canon EOS 20D, 17-40 mm zoom @ 17 mm, 9 secs, f/16, ISO 100

right Canon EOS 5D Mk II, 28-70 mm zoom @ 52 mm, 15 secs, f/8, ISO 100

A long, single exposure will start to record the ambient light as well as the fireworks. This can work well in some situations, but if you want to avoid it, try "capping" the lens between explosions.

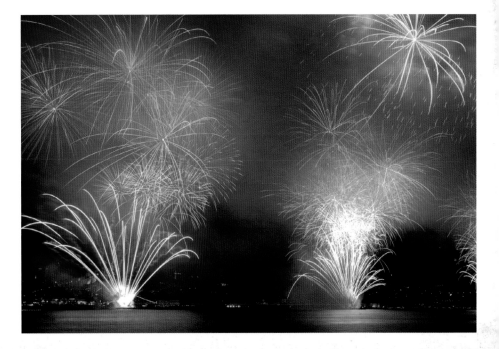

Painting with light

So far, we have focused on how to record the ambient light in low-light scenes, but here we are going to investigate a more proactive approach—adding targeted light to a scene. More commonly known as "painting with light," there are two main ways is which this can be done, but both require an ultra-long shutter speed so you've got enough time to add the additional light. For fairly simple scenes this might mean that you just need a few extra seconds, while for more complex images it's likely that you will need at least a couple of minutes. If you're shooting in total darkness you can leave the shutter open until you have added the light you need, but if you're shooting when the ambient light is brighter you will need to make sure that you control the duration of the exposure so the ambient light doesn't overpower the light you want to add. In most instances, this is simply a matter of shooting a few test exposures and determining the optimum aperture and shutter speed.

Painting with light using flash

One of the simplest forms of painting with light can be done using a conventional off-camera flash with a test firing button. In near or total darkness, move around the scene, popping the flash to add light to different areas. In most cases, the result could also be achieved using multiple flash units, but painting with light has several important benefits. The first is that you can use a single flash, which means you can light an entire scene using one, inexpensive, low-powered device, firing it more times, from different angles to build up a more complex lighting array.

As a typical light-painted shot takes place over several minutes you can move around within the frame as though you were invisible. This is because you will only occupy a specific area of the frame for very short periods, so your impact on the exposure as a whole will be negligible. In practice, this means you can place your flash within the

frame and—providing it isn't pointing toward the camera—the way in which the light was applied won't be obvious. For example, you could add a burst of colored light to a small section of an image, confident that this won't spill over and illuminate other areas of the scene.

In principle, painting with light is relatively simple, but because each shot is different there are no hard-and-fast rules. As a guide, start by setting your camera to B (Bulb), select a low ISO (100 or 200), and set the aperture to f/8 and the flash to 1/16 power if it allows you to vary the output.

Then, open the shutter and move around the scene, triggering your flash to illuminate specific areas of the scene. Once the image has been taken you can use your camera's screen to see which areas have been properly exposed and which haven't. It will probably take a few goes to get the right amount of light on each area, and you might find you need to fire the flash several times, or increase its power to light some parts of the picture.

above: **Canon EOS 40D, 10-20 mm zoom @ 12 mm, 30 secs, f/5, ISO 100**

This is a single 30 second exposure shot at f/5, painted with numerous flash bursts to the outside of the aircraft, plus an extra flash burst within the fuselage using a red gel over the flash head.

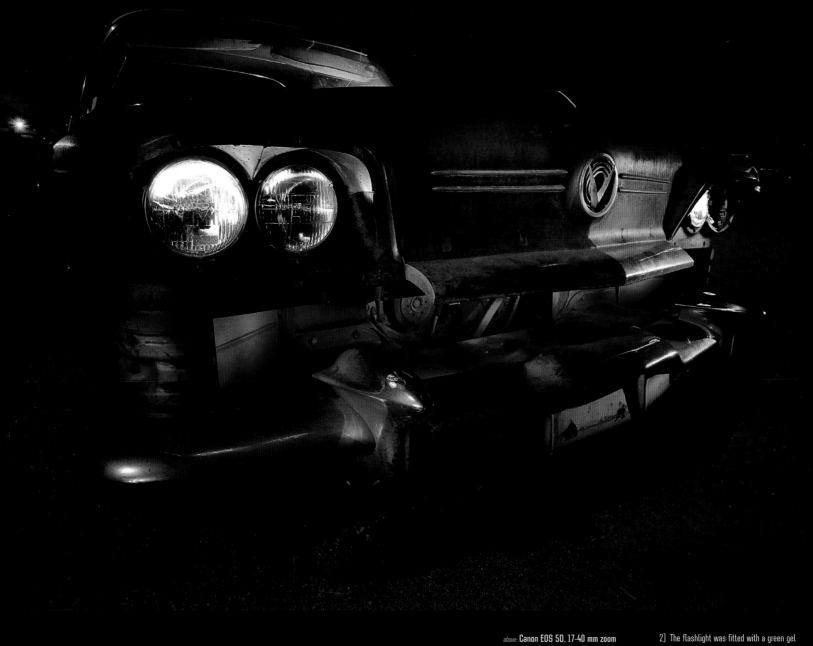

above: **Canon EOS 5D, 17-40 mm zoom @ 21 mm, f/11, ISO 200**

This image is a combination of five light painting stages, using a flashlight and a tiny LED light:

1] A flashlight was used to add light to the interior of the car

2] The flashlight was fitted with a green gel to paint the left side of the car

3] The flashlight was fitted with a red gel to paint the right side of the car

4] More red light was added to the grille area

5] The headlights were traced using a tiny LED

opposite: **Nikon D200, 28 mm lens, 30 secs, f/16, ISO 100**

A single 30 second exposure, shot in a completely dark room and illuminated using a small flashlight. The light trails are caused by the light being aimed at the camera, rather than away from it.

above: **Canon EOS 5D, 17-40 mm zoom @ 35 mm lens, 30 secs, f/13, ISO 100**

This is a combination of 11 exposures: Ten to illuminate each car in turn using a sparkler, and a final shot to capture the pre-dawn ambient light. The sparkler exposures were blended in Photoshop using the Screen blending mode, with the final shot masked and blended using the Normal blend mode.

Painting with light using other light sources

While painting with light using a flash unit provides a high degree of control, seeing precisely where you will be "painting" is impossible. This means it's far easier to use a flashlight, which you can aim with much greater precision. You can also adjust its effect by varying the amount of time you spend on each area of the scene, the speed you move its beam through the scene, and its distance from the subject. The downside is a regular flashlight will not be as bright as a flash, so exposure times will need to be longer.

An extension of this technique—and one that produces a very different type of image—is to turn the flashlight around and point it toward the camera, rather than at the objects in the scene. Used in this way the light becomes a component of the image, rather than just a means of illuminating it, which can produce very interesting results.

You can use any sort of light to add this effect: a flashlight, an LED bulb, a sparkler—anything that acts as a light source. In practice though, getting this type of shot right requires a lot of forethought, because you need know exactly where you want the light to appear. Once you have decided, set a long shutter speed (or use your camera's Bulb mode), move the light through the scene to create the visualized effect, and then close the shutter. This is a technique that requires a lot of practice, but it's fun to try, and because the result is unrepeatable it's capable of producing unique images.

Using filters to extend exposures

You have seen how to capture a variety of scenes using ultra-long shutter speeds, but most of the scenarios discussed so far share one common factor—the ambient light levels have been low, making extreme exposure times almost a necessity. However, there's no reason why exposure times can't be extended in daylight, so you can record movement in a subject, even in bright conditions. All you need is to reduce the amount of light reaching the sensor.

The easiest way to do this is by using a neutral density (ND) filter, or several ND filters in combination. Neutral density filters are constructed from partially opaque resin or glass and are designed to block a fixed amount of light, without affecting the color of the image (hence "neutral" density).

The amount of light a particular ND filter blocks is expressed in stops, with one, two, and three stop filters readily available from most filter manufacturers. Their effect is fairly self-explanatory; a one stop filter lets you extend an exposure by one stop, or one EV (extending it from 1/30 sec to 1/15 sec, for example); a two stop filter extends an exposure by two EV (1/30 sec to 1/8 sec); and a three stop ND filter will let you extend the exposure time by three stops (1/30 sec to 1/4 sec). Some manufacturers produce much stronger ND filters—up to 13 stops in some cases.

ND filters are available as round, screw-in filters, or as square filters that can be mounted to your camera using a filter holder. While the screw-in variety tend to be cheaper, I'd recommend investing in a filter holder and one or more square, slot-in ND filters. While the holder and filter(s) might cost more initially, if you intend to use them with multiple lenses it's much cheaper to buy several adapters so you can mount them on each of your lenses than to buy screw-in filters that will only fit a specific lens diameter. A filter holder will also make it much easier to stack ND filters as you could use a 0.9 ND and 0.6 ND filter at the same time, for example, to reduce the light by five stops. Screw-in

filters can also be stacked, but this can cause problems if you are shooting with wide-angle lenses as the rim of the front filter may be visible in the shot, creating vignetting (corner-shading) in the final image.

Whether you choose screw-fit or slot-in ND filters, either alone or stacked, the filters themselves are very easy to use—simply attach them to your camera, compose your shot, and shoot as normal. Because your digital SLR's through-the-lens metering system takes the exposure reading through any filters that are fitted there are no special exposure requirements. The only downside is that the image you see through your viewfinder will be darker because you are seeing through the filter(s). If this is a problem, compose and focus manually without the filter(s) attached, and then attach the filters and shoot as normal.

below: **Canon 5D Mk II, 17-40 mm zoom @ 21 mm, 30 secs, f/11, ISO 50**

A 9½-stop neutral density filter extended the exposure time for this daytime shot to 30 seconds, transforming the water into a soft mist. A 3-stop graduated neutral density filter was also used, to balance the bright sky.

opposite: **Canon EOS Rebel, 10-20 mm zoom @ 10 mm, 100 secs, f/11, ISO 100**

Although water is the common subject for ultra-long daylight exposures, in this photograph a strong, 13-stop ND filter has provided an ultra-slow shutter speed that records the movement of the clouds, adding even more drama to the sunset scene.

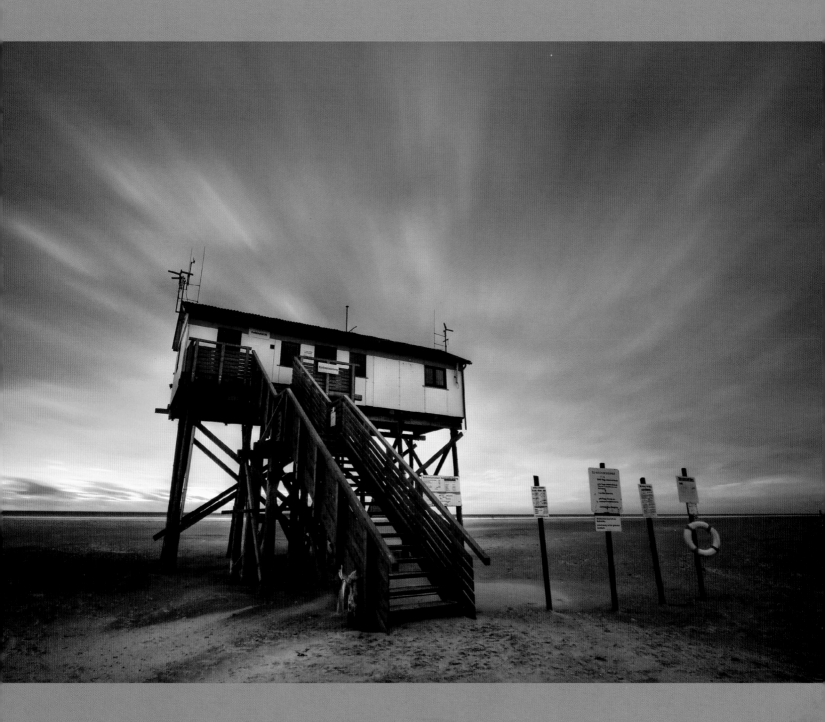

Motion blur

Although we've concentrated on using an ultra-long shutter speed to create stunning imagery in a variety of situations, all of the techniques so far have one thing in common—the camera is locked down on a tripod or similar support. But there's nothing to stop you from liberating your camera, handholding it or loosening the tripod so you can introduce intentional blur into an image. By panning a static scene, rotating your camera during an exposure, or randomly moving your camera, you can deliberately introduce camera shake, creating beautiful, abstract, eye-catching imagery from even mundane subjects.

Panning

Panning a static scene immediately gives the impression that a scene is racing past the camera, as if photographed from a fast-moving train or car. The extent to which the final image will be blurred depends on two factors: the speed at which you pan and the duration of the exposure.

To produce a reasonably smooth image, mount the camera on a tripod, but loosen the head so you can make a slow panning movement in a single direction, with the shutter speed set between 1/4 sec and 1 second (using Shutter Priority mode). Typically, the scenes that work best contain a strong horizontal or vertical component. If you pan a scene that is rich with detail, all you will end up with is a colored blur, but if you pan horizontally across a scene with a strong horizontal component—a seascape with a clearly defined horizon, for example—the horizon will remain relatively sharp and readable, but the colors will blend together to create smooth bands of color. Similarly, if you were panning a skyscraper, an upward or downward pan would emphasize the strong vertical lines created by the sides of the building.

Rotation

While panning a static subject can be effective, there's no reason why the camera movement can't be more disjointed—by rotating it during an exposure, for example. Rotation works best when the camera is relatively stationary for sections of the exposure, allowing it to capture some of the detail within the original scene. An exposure of several seconds gives you time to rotate the camera, hold it still, rotate it again, and so on, so set your camera to Shutter Priority, choose the lowest ISO setting, and set the exposure time to 2–4 seconds. Don't worry if the camera selects a small aperture as the depth of field is irrelevant—you will be moving the camera so the result is going to be deliberately blurred.

above: **Canon EOS 40D, 24-105 mm zoom @ 40 mm, 0.4 secs, f/11, ISO 250**

Panning horizontally during a long exposure blends the colors in this seascape image, but the horizontal movement doesn't disrupt the horizon: The image still "reads" as a seascape.

opposite: **Canon EOS 20D, 17-40 mm zoom @ 17 mm, 2.5 secs, f/22, ISO 100**

This photograph of a stairwell lit by fluorescent lighting has been transformed from an uninspiring concrete construction into a monochromatic abstract image through rotation blur.

INTENTIONAL CAMERA SHAKE

Camera shake is normally something photographers strive to avoid at all costs, but it can be utilized to create unique and striking images. In this example I set the ISO to 80 on a point-and-shoot-style camera and attempted to hold it as steady as possible during the resulting 13 second exposure.

Obviously, I didn't expect to get a pin-sharp result, but the image does show some identifiable details. Other areas are blurred beyond recognition, conveying a much greater sense of motion than would have been achieved with a conventional exposure.

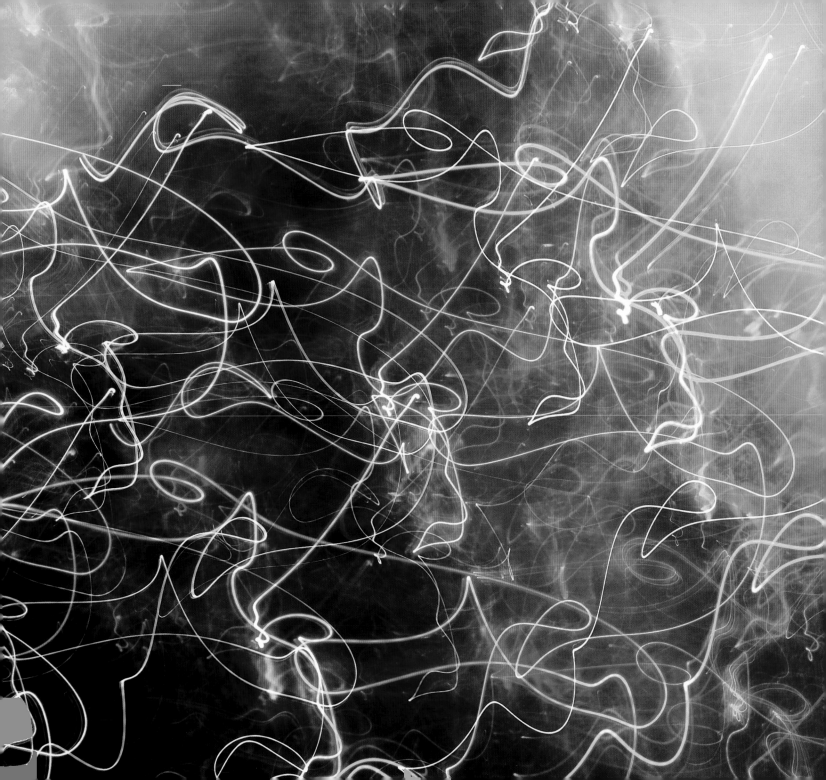

Random movement

Most of the time, waving your camera around during an exposure will produce nothing more than a blurred mess, but with bright, point-light sources, this technique can transform them into an abstract trail of lights with the striking intensity of a Jackson Pollock "drip" painting. This example is the result of a 4 second exposure of the lights on a Christmas tree. By randomly moving the camera during the exposure, the lights appear to dance around the image, creating a purely abstract result. As with most of these techniques, set a long exposure in Shutter Priority mode so you have time to introduce enough motion into the scene to create an interesting image.

Esthetic considerations

While the previous examples are interesting applications of motion-inducing techniques, most were shot without much thought about their creative impact. However, this final set of images (part of a much larger sequence produced by Christine Glade between 2008 and 2009), was created with a single aim: To use "intense color and movement" to capture the "energy, beauty, and vitality" of flowers in her husband's garden.

"By using a small aperture and long shutter speed, I was able to transform the flowers into something besides the petals and stems they normally appear to be. By sweeping across the flowers as the picture was being taken, and "painting" with the camera, I became keenly aware that color—a wonderful thing to behold—is also a verb."

3. ULTRA-SHORT SHUTTER SPEEDS

Natural light, short exposures

Ultra-short shutter speeds are essential if you want to freeze motion, allowing you to record a fleeting moment in time—even those imperceptible to the eye—with all its detail. However, minimizing the amount of time that the shutter remains open restricts the amount of light that is recorded, so there are three things you need to bear in mind; the brightness of the scene you are photographing, the maximum aperture you can use, and how far you are willing to increase the ISO.

As you will remember from chapter one, the brightness of a scene can be expressed in EV, and each exposure value determines the combinations of aperture and shutter speed you can use to create an optimum exposure. For example, a typical scene in full sunlight has an EV of 15. When shooting at f/2.8 at ISO 100, you would need a shutter speed of 1/4000 sec to get the correct exposure, but shooting the same scene on a heavily overcast day (EV 12) would mean using a shutter speed of 1/500 sec to maintain the same aperture and ISO settings. This might suggest that shooting when the sun is at its brightest is the best answer when you want to use the fastest possible shutter speed, but from an esthetic point of view this might not be ideal. Strong directional sunlight might provide the quantity of light you need, but it doesn't always provide the right *quality* of light. Direct sunlight is always very harsh, which causes a range of technical problems, such as very dense shadows, or a high dynamic range that means you have to sacrifice highlight detail, shadow detail, or both.

A second issue that arises if you want to use a fast, action-freezing shutter speed is that you will almost certainly need to use a wide aperture. This is fine if you're happy with a shallow depth of field, but it's no help if you want more of the image to appear sharp. The answer, of course, is to increase the ISO so you can use a fast shutter speed *and* a small aperture, but you'll immediately be increasing noise, and this can start to degrade the image.

Ultimately, what this all means is that using ultra-short shutter speeds can involve some degree of compromise, whether it's the aperture and depth of field, or the ISO and noise. Don't let this put you off, though—there might be compromises involved, but ultra-short shutter speeds are still capable of producing images that can record split-seconds of time that are either invisible to the human eye, or pass too quickly to be truly appreciated.

above: **Canon EOS 1Ds Mk II, 24-70 mm zoom @ 38 mm, 1/2000 sec, f/8, ISO 100**

This striking image required an ultra-short shutter speed to not only freeze the action of the silhouetted soccer player, but also to prevent the sky—with the sun in the frame—from appearing heavily overexposed.

opposite: **Canon EOS 20D, 17-40 mm zoom @ 40 mm, 1/800 sec, f/7.1, ISO 100**

An ultra-short shutter speed is the only answer if you want to guarantee sharp pictures of fast-moving subjects. Timing is equally important for positioning the subject.

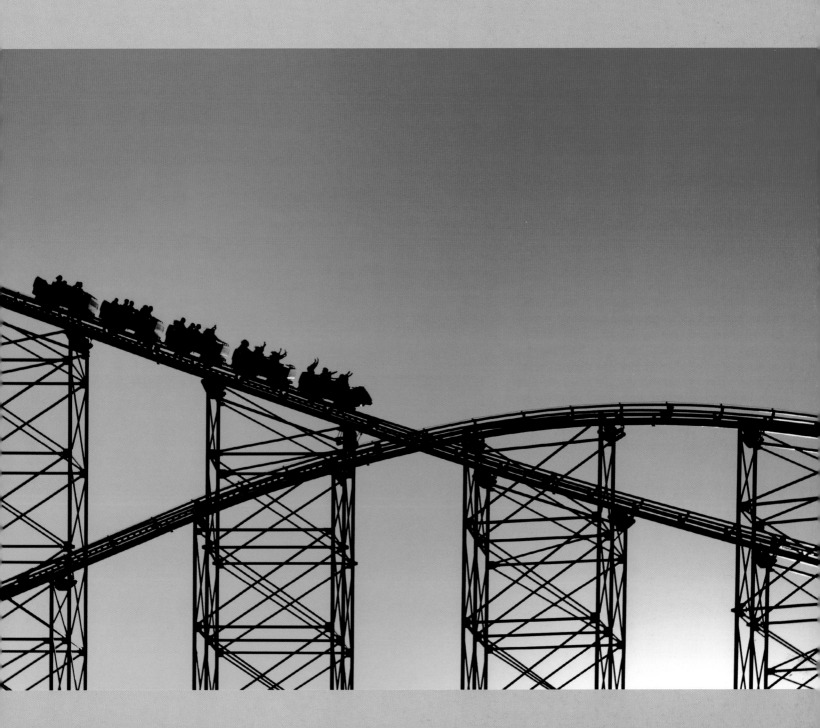

Subject moving, camera fixed

It goes without saying that the faster a subject is moving, the faster the shutter speed required to freeze the movement, but the speed of your subject is not the only issue. For a start, subject distance plays a part. Moving subjects that are close to the camera will appear to move more than those farther away, so a closer subjects requires a faster shutter speed. The direction of the movement is also significant—subjects moving across the frame will appear to move more than those heading directly toward or away from the camera, so again lateral movement means a faster shutter speed.

With a digital camera it's usually easy to establish the correct shutter speed for a shot—you simply make a test exposure and check the image on the camera's screen. If the shot is blurred, you can adjust your shutter speed accordingly, and shoot again. This is great, but it only works if you have the opportunity to retake the shot and by its very nature, a moving subject is unlikely to be in the same place when you come to shoot again. If you are in any doubt over the "correct" shutter speed to freeze movement then the simple rule is to use the fastest shutter speed you can—the faster the shutter speed, the sharper the image.

To maximize the control you have, it's best to switch your camera to Shutter Priority mode. This will let you to set the shutter speed you want, and in ideal conditions your camera will choose an appropriate aperture. However, when the light levels are low, choosing a fast shutter speed can lead to underexposure. For example, if you were shooting on an overcast day (EV 12), a shutter speed of 1/1000 sec would require you to shoot at f/2 (at ISO 100). But if your lens has a maximum aperture of f/4 this means the image will be underexposed by 2 EV. This gives you three options: Lower the shutter speed to 1/250 sec and risk slight blurring, increase the ISO by 2 stops and introduce more noise, or adjust both by one stop. Either way, it's a question of compromise.

above: **Canon EOS 20D, 17-40 mm zoom @ 17 mm, 1/500 sec, f/8, ISO 100**

While the speed of your subject has a huge impact on the shutter speed you need to freeze its motion, its distance from the camera, and the direction of its movement is also important. The girl in this shot is close to the camera and moving across the frame, and despite not moving very fast, a fast shutter speed of 1/500 sec still reveals motion blur in her feet.

opposite: **Canon EOS 40D, 70-210 mm zoom @ 210 mm, 1/1000 sec, f/5.6, ISO 200**

The combination of bright backlighting and fast-paced action demands an ultra-short shutter speed to freeze the moment. A fast shutter speed also lets you handhold the camera with longer lenses, without the risk of introducing camera shake.

Panning

As well as using an ultra-short shutter speed to freeze motion you can also help make sure the subject remains sharp by panning with your camera—a technique that can also come to your aid when the lighting means you have to compromise with the shutter speed. A creative offshoot of panning with a moving subject is that the subject will remain sharp, but the background can become blurred. This simple visual effect enhances the notion of movement and injects a sense of speed into an image.

Panning most likely needs no introduction—the basic aim is to track the movement of the subject as it passes the camera. This can be done with the camera mounted on a tripod, but make sure the tripod head is unlocked in at least one direction so you can turn the camera to follow the subject, or you can pan with the camera handheld. If you choose to handhold the camera, stand with your feet roughly shoulder-width apart and turn your body from the waist to track your subject as it passes. This will produce the smoothest panning action, and in conjunction with lens-based or sensor-based stabilization it will mean you get the sharpest result. You also need to accurately track the subject, and make sure the entire exposure falls within the duration of the pan. The easiest way to do this is to start panning/tracking the subject as it approaches and then trigger the shutter when your subject is where you want it to be, and only stop panning once the shutter has closed.

left: Nikon D70s, 50 mm lens, 1/30 sec, f/2.8, ISO 400

Panning is an effective technique regardless of the shutter speed you are using. For this shot, the exposure was a modest 1/30 sec, but panning has recorded the subject sharply.

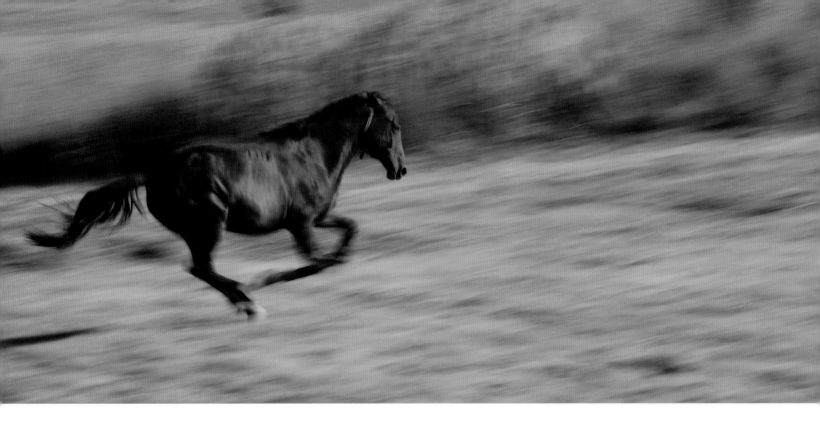

Speed and direction

Although panning is easy to understand and implement, there are some technical issues that need to be remembered. For a start, you should aim to pan with subjects that are moving parallel to the plane of your camera's sensor. This is because an object moving toward the camera will appear to increase in size, while one moving away will appear to shrink. Panning with a subject that remains relatively constant in size—one that is moving across the frame—is more likely to produce a sharp image. You also need to think about the speed of your subject. It's easy to think that just using an ultra-short shutter speed will be enough to freeze *all* motion, but panning is still a better way of making sure very fast subjects remain sharp. For example, an object traveling at 100 mph will travel almost 2 inches (5 cm) during a 1/1000 sec exposure. This might not sound like a huge distance, but it's more than enough to take the edge off any detail if your camera remains stationary during the exposure.

In principle, the skills you need for high-speed panning are no different than those you need for low-speed panning—you just need to move a lot faster. For example, a racing car traveling at 200 mph will cover a distance of almost 300 feet (90 meters) in a second, so it will speed past you in the blink of an eye. Because of this, you will probably find your initial attempts at photographing fast-moving subjects are less than perfect. It's easy to miss the subject entirely or accidentally crop the front or rear of a vehicle, but persevere and you'll soon find yourself getting more hits than misses.

above: **Canon EOS 5D Mk II, 70-200 mm zoom @ 190 mm, 1/30 sec, f/25, ISO 200**

Panning is all about tracking the subject for the duration of the exposure. Start panning before you trigger the shutter, and stop once the exposure has ended for the best results. The hardest part is to follow the subject while the viewfinder has "blacked out," but with practice this becomes easier.

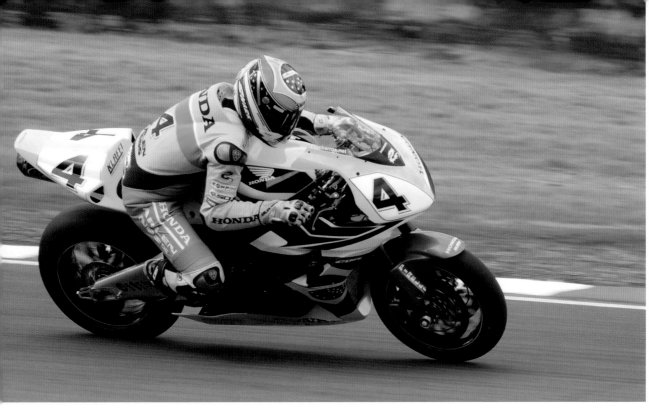

left: Pentax K100D, 70-200 mm zoom @ 170 mm, 1/500 sec, f/8, ISO 800

Although the distance this motorbike would cover during 1/500 sec isn't great, it would be enough to produce a blurred picture. Panning ensures the rider is as sharp as possible, while defocusing the background and enhancing the sense of speed.

below left: Canon EOS 5D, 17-40 mm zoom @ 40 mm, 1/8 sec, f/4, ISO 100

The best panning shots are those taken when the subject remains the same size in the frame—moving laterally in front of the camera rather than toward or away from you.

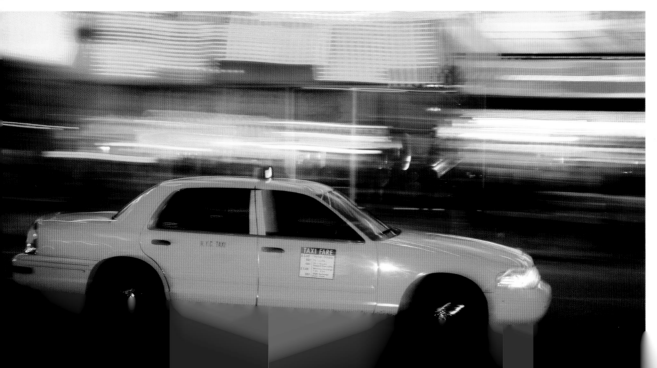

Flash equipment and techniques

One of the biggest problems with using an ultra-short shutter speed in daylight conditions—especially with a small aperture—is that there is often not enough light. Although you can raise the ISO (and reduce image quality), an alternative is to add light to the scene using a flash.

Dedicated flash units

A "dedicated" flash is the simplest and most versatile type of flash to use as it is designed to communicate with the digital SLR body (and lens) to determine the optimum exposure. It does this using an advanced form of through-the-lens (TTL) metering, such as Canon's E-TTL II flash metering, or Nikon's i-TTL. Both operate in a similar way; by firing a brief pre-flash that is read by the same in-camera sensor that measures the ambient light. The pre-flash exposure information is evaluated in conjunction with the lens-to-subject distance and used to calculate the ratio of the flash to the ambient light. In a split-second, this determines the output of the flash.

Manual flash units

Unlike a dedicated flash, a manual flash unit doesn't necessarily communicate with your camera, which means you have to take more control. With some manual flashes there's the option of changing the power output, but with others there is not—either way, it's all about setting the right exposure for the result you want.

The easiest way to do this is by using a flashmeter, which will measure the light from the flash and tell you the aperture you need to use at any given ISO. The reason the flashmeter will tell you the aperture to use—rather than giving you an aperture and shutter speed combination—is because the aperture is considerably more important in terms of determining the overall exposure when you're using flash. This is because the duration of a flash unit is

extremely short; something on the order of 1/3000 sec at full power. If the flash is the sole source of illumination (in a blacked-out room, for example), the camera's shutter speed is irrelevant, as the flash will fully expose the subject in 1/3000 sec, regardless of whether you set a shutter speed of 1/250 sec, or 2 seconds. Where the shutter speed comes into play is when flash is mixed with ambient light. In these situations, the flash exposure is still ultra-short, but the shutter speed determines how much of the ambient light is recorded. A 1/60 sec exposure will allow twice as much of the ambient light to reach your sensor as a shutter speed of 1/125 sec, for example. In this way, the aperture controls the flash exposure, while the shutter speed controls the exposure for the ambient light.

Manual flash and flashmeter

Although you can control the power of some manual flash units, the exposure is something you may have to work out yourself. This can make a flashmeter invaluable.

Nikon Speedlight SB-900

Dedicated flash units, such as this Nikon Speedlight, communicate with the camera to determine the optimum flash output based on the ambient light, subject distance, and more.

FLASH POWER

The power of most hotshoe-mounted flash units is usually expressed as a guide number. For example, the Canon Speedlite 580EX II has a guide number of 190 feet (58 m) at ISO 100. This means the flash is capable of illuminating a subject 190 feet (58 m) away when it is switched to full power, using an aperture of f/1.0 and ISO 100.

Although the guide number is based on a theoretical aperture of f/1.0, it can still be used to determine the ideal aperture setting for a flash exposure—simply divide the guide number by the shooting distance. For example, if your flash has a guide number of 190 feet (58 m), and your subject is 19 feet (5.8 m) away, you would need to use an aperture of f/10 (at ISO 100).

Canon EOS 1Ds Mark II, 70-200 mm zoom @ 200 mm, 1/250 sec, f/13.0, ISO 100

For this portrait I used off-camera flash to light the subject. Because of the
flash-to-subject distance, the flash needed to be set manually to 1/8 power.

Off-camera flash

The main problem with your camera's built-in flash, or even a hotshoe-mounted flash, is that it points directly at your subject and is close to the camera's lens, which can result in harsh lighting and red-eye, to name but two problems. The light also dissipates with distance, so an object 6 feet (1.8 m) from the camera receives only 1/4 of the light that would hit an object 3 feet (0.9 m) away. Likewise, an object 12 feet (3.6 m) away receives only 1/16 of the light. Known as the "inverse square law," this is why using direct, on-camera flash can result in a perfectly illuminated foreground, but a very dark background.

There are a number of ways you can avoid this. If your flash has a head that will move, you can bounce the light from the ceiling or a wall, for example, which will help prevent red-eye. As you are effectively increasing the distance it travels, this will also make it softer and more diffuse.

Alternatively, you can move the flash away from the camera. This will revolutionize the creative scope of your flash, allowing you to light a subject from the side, from behind, from below—in fact, from wherever you can position the flash. The main ways of getting your flash off-camera are to use a dedicated flash cable (which restricts the flash position to the length of the cable) or a wireless trigger. Wireless triggers can range from optical slave cells that fire the flash when another flash is detected (such as your camera's built-in flash), through to infrared remote triggers and radio transmitters.

There are a variety of ways that you can use your flash off-camera, including optical slave cells (above), wireless triggers (top left), or dedicated flash control cables (top right).

COLOR TEMPERATURE

Different light sources have different color temperatures, but a flash is designed to output light at a consistent color temperature of 5500K (degrees Kelvin). This is roughly equivalent to the color temperature of sunlight at noon, which means the color temperature of the ambient light and flash will be balanced if you're shooting at noon.

However, using flash at other times of day, when the ambient light appears either warmer or cooler, or shooting under a different ambient light source, such as domestic tungsten lighting, for example, can reveal a noticeable disparity between the two light sources. If you want to avoid this, use a colored gel over the flash so it is matched to the ambient light source. For example, if you are shooting an indoor scene lit by tungsten lamps, use a CTO (Color Temperature Orange) filter over the flash to match it to the tungsten light, and use a tungsten white

Mixing flash and ambient light

Unless you are shooting in total darkness, most flash exposures will require you to balance the flash with the ambient light. If you're using a dedicated flash, your camera's TTL flash metering system will do a good job at getting the overall exposure right, but the tendency is to produce an image that clearly looks like it has been lit by flash. So, if you want the flash to be less obvious—to add catchlights to a subject's eyes without the flash dominating the picture, for example—there will be times when you need to take more control, and you can do this either by using flash exposure compensation, or by switching your camera and flash to manual.

Flash exposure compensation

If you want to decrease the flash power to produce an image where the flash is less dominant, but still contributes to the image as a whole, flash exposure compensation is the easy answer. Like your camera's exposure compensation feature, it adjusts the exposure, but rather than altering the shutter speed or aperture, it adjusts the power output of the flash— simply dial in -1/2 EV of flash exposure compensation and you immediately reduce the intensity of the flash by half a stop, for example. With some digital SLRs this is something that you control from the camera, while others might need you to make the adjustment on the flash unit.

However, flash exposure compensation isn't just about reducing the effect of the flash—you can also exaggerate its impact by dialling in positive flash exposure compensation. Alternatively, if you leave the flash at its default value and decrease the exposure for the ambient light using minus *exposure* compensation you can darken the background (the ambient light), and enhance the flash. This can be an effective way of drawing the viewer's attention to the flash-lit areas of an image.

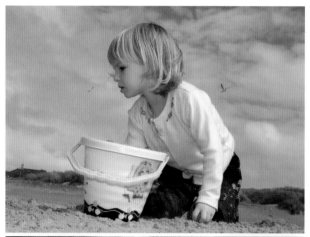

left: Canon PowerShot G9, 1/640 sec, f/6.3, ISO 50

Shot using the metered exposure and -2/3 EV flash exposure compensation to produce an image where the ambient light is recorded faithfully, and the contribution of the flash is less obvious.

below left: Canon EOS 20D, 24 mm lens, 1/1250 sec, f/4.0, ISO 100

Shot using -2/3 EV *exposure* compensation, without flash exposure compensation. As a result, the background—lit by the ambient light—has been underexposed, while the flash has delivered the correct exposure for the subject.

opposite: Canon EOS 30D, 24-70 mm zoom @ 38 mm, 1/250 sec, f/10, ISO 100

This was shot in manual mode, using an aperture of f/10. The quad bike was lit by two off-camera flash units set to deliver the right amount of light for the aperture setting, but a shutter speed was deliberately chosen that would underexpose the ambient light on the background by two stops.

Working in manual

For the greatest degree of control over your images, nothing beats switching both your camera and flash to manual. A flashmeter is essential as you need to set the power output on your flash, and determine exactly the right combination of aperture, shutter speed, and ISO to record the ambient light. This also makes it a time-consuming technique, but the advantage is absolute control over your lighting, and the ratio between the ambient light and flash.

Flash synchronization

The fastest shutter speed you can use with flash on most SLRs is limited to around 1/200 sec or 1/250 sec, which is often referred to as the camera's *sync speed*. Using flash with a shutter speed that is faster than the sync speed means the sensor will only be exposed to a "slit" of light as the shutter opens and closes. This will leave the rest of the image underexposed, unless your camera is capable of high-speed synchronization as outlined opposite. At slower speeds, however, there is more time for the flash to fire, and in these situations you can decide when it is triggered—at the start of the exposure as the shutter opens, or at the end, just before it closes.

First Curtain Sync

The default setting for most cameras is to fire the flash at the earliest opportunity after the exposure has been started. Termed *first curtain sync*, this is fine for most situations, but when you are using longer shutter speeds with moving subjects it can lead to images that look slightly strange.

The reason they look strange is because the flash immediately "freezes" the subject, but the ambient exposure continues to record the movement. As a result, the subject will be sharp and well-lit at the start of the exposure, but there will be a blur that appears in front of them as they move. As we perceive motion blur as something that trails behind a moving object—not something that appears in front of it—this can look unusual.

Canon EOS 40D, 20 mm lens, 1/6 sec, f/14, ISO 100, 1st curtain sync

HIGH SPEED SYNC

An additional form of flash synchronization that you might come across with some camera models is High Speed Sync. In this mode, the flash remains illuminated throughout the exposure by emitting thousands of low power flashes per second, instead of a single burst of light. The short, high-speed flashes merge together so the camera's sensor is evenly illuminated, even when the exposure time is much shorter than the camera's sync speed.

Second Curtain Sync

For more natural-looking motion in flash photographs, you should switch your flash to second curtain synchronization. In this mode, the flash is triggered just before the exposure ends. This means any movement is recorded by the ambient light first, with the flash freezing the subject at the end of the exposure. Any blurred movement will appear behind the subject, effectively creating a "speed blur."

Second curtain sync is slightly more difficult to use than first curtain, simply because you need to estimate where the subject will be at the end of the exposure, when the flash fires—not easy when your SLR's viewfinder blacks out as the exposure is being made. Consider adjusting your composition to accommodate this, or zoom out or step back so the subject has more space in the frame. You can always crop the image later.

Canon EOS 40D, 12 mm lens, 1/15 sec, f/4.0, ISO 160, 2nd curtain sync

Freezing movement with flash

As the duration of a typical burst of flash is very short, this makes it a great tool for freezing movement, especially when the ambient light levels are low. However, it is not without technical problems. Imagine, for example, that you are shooting in reasonably bright conditions. You want your main subject to be primarily flash-lit, but you also want the background to be quite dark. You can control the amount of ambient light reaching the camera's sensor by adjusting the shutter speed, but the flash will be limited to your camera's maximum sync speed, which might not be fast enough to darken the background sufficiently.

In this case, the obvious option is to decrease the size of the aperture—from f/5.6 to f/11 to reduce the exposure by two stops, for example. This would work, were it not for one major stumbling block—changing the aperture will affect the flash exposure, and you might find your flash cannot produce enough light to give a full exposure. This means you either need to use a more powerful flash unit, move the flash closer to the subject, increase the ISO on your camera, or wait until the ambient light level is lower.

The best option is to wait: When the light levels are lower, your ability to control the ratio between the ambient light and flash dramatically increases. For example, the EV value of a typical scene just after sunset is around 9 EV. When shooting at 1/250 sec, the aperture you would need to capture the ambient light would be f/1.4. Setting an aperture of f/2 would allow you to underexpose the ambient light by one stop, f/2.8 by two stops, through to five stops underexposed at f/8. This increases the potential you have to creatively manipulate the amount of ambient light you record, letting you underexpose by a small amount to focus the viewer's attention on a flash-lit subject, or "cancel out" the ambient light entirely.

above: Canon EOS 1D Mk II, 24 mm lens, 1/250 sec, f/7.1, ISO 200

This shot of a "flying" sportsman was taken at dusk using two flash units—an on-camera flash set to 1/2 power, and an off-camera flash set to 1/4 power, triggered by a radio transmitter. The shutter speed ensured the ambient light was eradicated to produce a black background.

opposite: Nikon D300, 10.5 mm lens, 1/250 sec, f/5.6, ISO 200

Flash isn't just a tool for freezing movement—it can also be used to add drama to a photograph, as in this urban photograph. Getting close to the subject with an ultra wide-angle lens and then setting the camera so the flash dominates the background helps create a gritty look.

A shot in the dark

When you shoot in very dark conditions, your scope for lighting a scene—and freezing the movement within it—is greatly enhanced, simply because the ambient light will have a negligible effect on the exposure. This puts you in a position where the only light present is that which you add yourself, giving total control over the quantity of light, its direction, its color, the diffusion, and so on. With the advent of digital cameras this process is made very easy because you can consult your camera's screen after each shot and adjust the lighting.

Although using a single flash is where most people start, using more than one flash is a step toward greater creativity. However, multiple flashes also increase the complexity of a shot, especially if you are using individual flash units to light different components within a scene. Not only do you need to adjust the power, distance, and direction of each flash individually, but you need to make sure that all the flashes fire at the same time, using either synchronization cables or wireless setups.

Light painting with a flash can also freeze movement, and it doesn't matter if you're using a single flash or multiple units. While the aim is to freeze the movement within a scene, the technique is exactly the same as discussed on page 62. You can either attempt to shoot a single, extended exposure and add multiple bursts of discrete light to the image, or you can shoot a range of different exposures that you can combine during post-production, as in the example shown here. Shooting separate exposures might sound like "cheating," but it's much easier to get things right if you're shooting individual pictures than trying to build up a single exposure using multiple flashes.

Canon EOS 5D, 17–40 mm lens @ 20 mm, four exposures, f/4, ISO 100

This image was constructed from four exposures. The first included the figure holding two flash units, while the remaining three were taken using a single flash to freeze the chair in different positions in the air.

High-speed flash

Although a typical flash duration is extremely short, the burst can be made even shorter if you lower the power output. This means you can freeze the most rapid movement, such as the splash of a water drop or the split-second that a bullet pierces a balloon. Photographing this sort of subject is challenging for a number of reasons, not least because it requires absolute precision if you want to capture an event that lasts only a fraction of a second. For example, you could watch a bottle being broken by a hammer, but with the naked eye it would be impossible to identify any exact points within the sequence—when the hammer first touches the bottle, when the debris has traveled 6 inches, and so on—simply because it happens too fast for our eyes and brain to register these moments.

Photographing it is harder still, as we not only have to "see" the moment, but also react to it and trigger the camera. In addition to our reaction speed is the time it takes for the camera to fire. With a digital SLR this comes down to the speed at which the mirror can be swung out of the way for the shot to be taken. This may seem instantaneous, but the reality is that it takes somewhere between 40 milliseconds (1/25 sec) and 100 milliseconds (1/10 sec). Add in your reaction time and the overall delay can mean the difference between getting the shot and missing it.

This would suggest that tripping the shutter at the exact right moment is more about luck than judgment and, for some people, using luck to capture the "perfect moment" is part of the fun. However, for those who don't want to rely on serendipity there is a more technical solution—you can use an automatic triggering system.

right: **Canon EOS 50D, 180 mm lens, 1 sec, f/9, ISO 100**

This photograph was shot using a light sensitive trigger and delay. An additional solenoid valve regulated the timing of the water drops so they could be recorded a split-second before they collided.

opposite: **Nikon D90, 105 mm lens, 1 sec, f/13, ISO 200**

The moment of impact, as a rifly pellet hits a frozen raspberry. Relying on luck alone to get the timing right would be impossible, but a flash trigger can be set to make the ultra-short flash exposure at the precise moment.

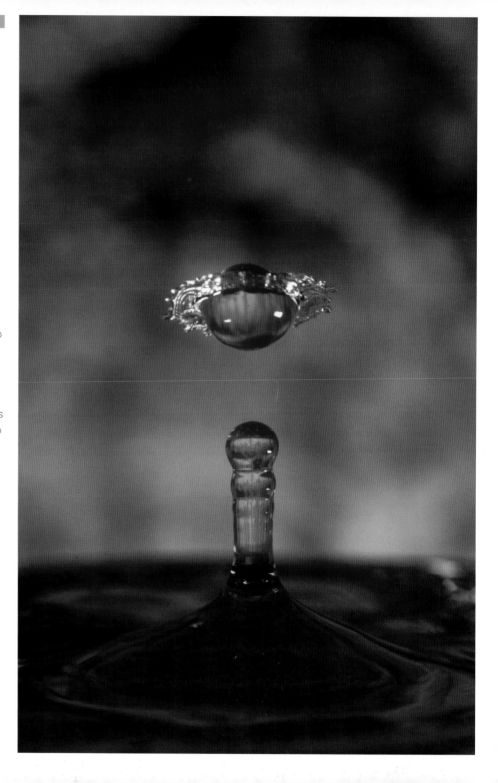

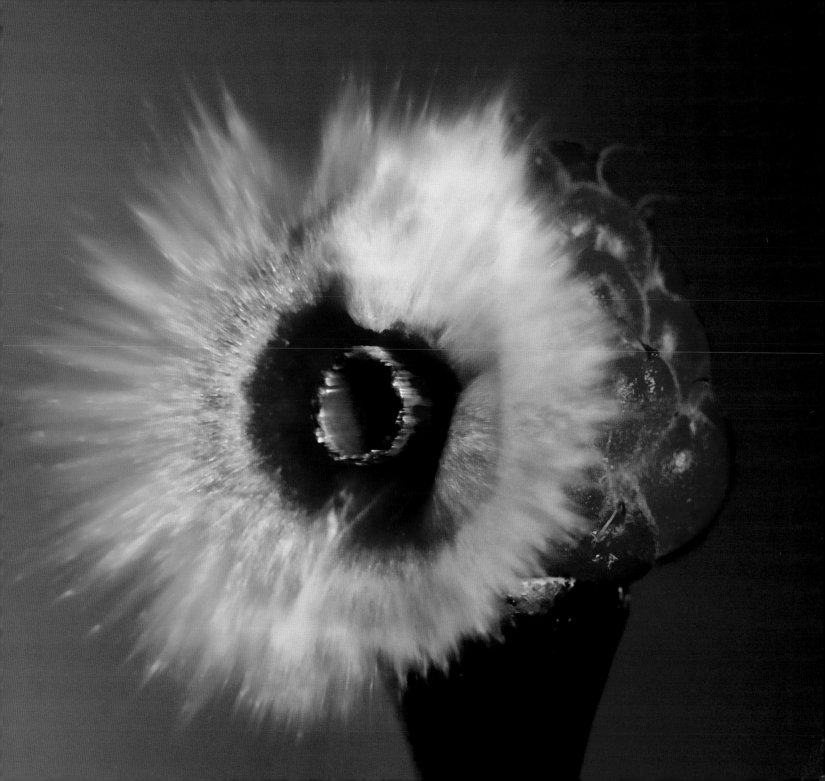

opposite: Nikon D90, 105 mm lens, 1 sec, f/16, ISO 400

left: Nikon D90, 18-55 mm zoom @ 55 mm, 1 sec, f/14, ISO 320

For this pair of images — of a rasberry in a plastic dinosaur's mouth, and a Christmas decoration filled with colored Jello exploding as they are shot with a rifle — an optical trigger or an audio trigger could be used. However, as with the raspberry on the previous page, a homemade optical unit was used in both instances.

Triggering systems

There are lots of different triggering systems you can make or buy, and they come in a variety of forms. But the one thing they all share is their ability to respond to an event and trigger a flash.

At this point it's worth noting that most high-speed shots are taken in either darkness or very low light, and despite appearing to utilize a split-second shutter speed, the opposite is actually true. The reason for shooting in darkness is that the ambient light is largely irrelevant— it is the ultra-short flash duration that freezes the subject, and this is most easily achieved when the shutter is open, so there is no lag while the mirror flips up.

In theory, a trigger can be constructed to respond to any event, as they are just relatively simple electronic devices that respond to a particular stimulus. However, the ones that are most useful for high-speed photography are those that respond to one of three inputs: Contact, sound, or movement. For example, a simple photogate trigger, such as the Schmitt trigger from hiviz.com/kits/spg.htm, contains just two parts: An emitter that sends out a beam of light, and a detector that receives the light. When the beam is broken, an electronic signal is sent and the flash is triggered.

To extend their usefulness, a trigger can be used in conjunction with a delay unit (the Schmitt Photogate-Delay Unit, for example) to compensate for the time it takes for the electronic signal to be sent from the trigger to the flash. These are especially useful when an identifiable trigger event will precede the actual moment you want to photograph. For example, a light sensitive trigger can be placed to respond to a falling drop of water, but a momentary delay can be programed so the flash fires the precise moment the drop strikes the surface, or the precise moment *after* it has struck.

Audio triggers

With an event where sound—rather than movement—is the most important signifier of the "action" you want to photograph, an audio trigger can be the better option. As with a beam-based trigger, these can be used in conjunction with a delay timer, as shown in the images of a hammer breaking beer bottles. These were recorded using delays of 50 and 100 milliseconds between the sound registering and the flash firing. Although there is only a 1/20 sec (50 ms) difference between the two exposures, the content of each is very different, which demonstrates the usefulness of a trigger-delay.

Triggering systems might sound complicated, but the equipment you need is often very cheap. For example, the SPG1-DU Schmitt Photogate-Delay Unit—a beam-based trigger and delay unit—is all you would need to produce simple water drop shots, and it costs less than $20.00 in kit form. Assuming you already own a flash unit, this is something that could help you produce uniquely interesting shots at a very minimal cost.

left: **Nikon D80, 100 mm lens, 5 secs, f/13, ISO 100**

To capture precise moments in time that are impossible to see with the eye, you can rely on serendipity or use a triggering system, but a trigger is the only way of making certain the effect is repeatable.

right: **Nikon D300, 50 mm lens, 10 seconds, f/5, ISO 200**

This pair of images demonstrates how an audio timer can be used in conjunction with a delay unit. Adjusting the delay between the signal and the flash firing creates two very different results from the same subject.

opposite: **Nikon D80, 100 mm lens, 5 secs, f/13, ISO 100**

Although the shutter was open for 5 seconds, it is the ultra-fast burst of flash that provides the exposure in high-speed photography like this shot of an exploding water-filled balloon.

100 MS DELAY

50 MS DELAY

above: **Canon EOS Digital Rebel XSi (400D), 135 mm lens, 1/180 sec, f/11, ISO 100**

A "raw" smoke shot should have detail in the lightest areas, and a black or near-black background. Use your camera's histogram to check your initial exposures and once your settings are correct you can simply keep shooting as the smoke forms interesting shapes.

left: **Canon EOS 20D, 100 mm lens, 1/200 sec, f/11, ISO 100**

You can enhance the abstract nature of smoke shots using your image-editing program. Here, I inverted the shot so the background changed from black to white, then used color adjustments to change the smoke from a drab gray into a more appealing copper-like color.

Shooting smoke

Although a motion or audio sensor is useful for some forms of high-speed photography, when it comes to the ethereal, abstract patterns of smoke, a trigger is unnecessary. This makes the technique very simple, although the results can be incredibly striking.

Working in a dimly lit room, start by setting up your camera on a tripod in front of your smoke source (incense sticks work well), with a black backdrop (card stock or velvet) behind. Position an off-camera flash to one side, or slightly behind the smoke source, and you're ready to go.

When it comes to choosing camera settings, you need to switch your camera to manual. You want to use a low ISO of 100-200 for optimum image quality, and set the shutter speed to the camera's maximum sync speed (1/200 sec or 1/250 sec). Next, set a reasonably small aperture (f/8-f/16), so the depth of field is large enough to make sure the smoke will be as sharp as possible as it blows in front of the camera. Finally, set the focus manually, light your incense, and take a test shot with your flash set to full power.

You can now assess the exposure to see if your settings are working. The key here is not to change anything on the camera—it's your flash that you will use to increase or decrease the exposure. If the histogram shows your first shot is underexposed, move the flash closer to the smoke, or move it away from the smoke (or reduce its power) if your test shot is overexposed. You are aiming for a black (or near-black) background, where the lightest areas of the smoke do not appear as pure white.

Once you have a good histogram you can start shooting for real. There's no need to look through the viewfinder, as your camera's already set, so simply watch the smoke and shoot when it forms interesting shapes or patterns.

below: Nikon D3, 24-70 mm zoom @ 70 mm, 1/250 sec. f/18. ISO 400

The way you post-process your smoke shots can be as subtle or as extreme as you like. In this shot, the smoke was rotated so it goes across, rather than up the frame, then it was inverted to create a white background. Finally, a rainbow effect was added, which results in an image that is as striking as it is abstract.

4. ULTRA-WIDE APERTURES

Wide aperture lenses

In the most basic sense, a lens with a large aperture will let you shoot in lower light conditions with a reasonable shutter speed. For example, a lens with a maximum aperture of f/1.8 is two stops faster than an f/3.5 lens, so you could use a shutter speed of 1/60 sec where the slower lens would require a 1/15 sec exposure time, for example. As a result, the risk of a blurred image through camera shake is reduced. However, that's just the basic mechanics, and as we've seen already, the aperture directly controls the depth of field and this is where you can start getting creative with your picture making.

Extreme, ultra-wide apertures will minimize the depth of field in an image, creating images in which subjects stand out from their background as their razor-sharp features contrast with their smoothly defocused surroundings. Unfortunately though, wide aperture lenses come at a price, and fast, f/2.8 zooms or f/1.2 fixed focal length (prime) lenses, are always going to be more expensive than equivalent focal lengths with smaller maximum apertures. There are plenty of reasons why this is, but fundamentally, the glass lens elements need to be physically larger, so they cost more in materials, and the lens needs to be manufactured to tighter tolerances, meaning more "rejected" (and costly) materials. When you add in the lower demand for the finished product, the price needs to be increased to justify the existence of the lens. The bottom line is that wide aperture lenses often come attached to a prohibitively high price tag.

Fast, affordable, wide aperture lenses

The costs involved in manufacturing wide aperture lenses partly explains why modern digital SLRs often ship with a zoom lens with a maximum aperture of f/3.5-5.6—they're cheaper to make. Now, it's great that you can spend a fraction more than the price of a camera body and get yourself an SLR kit with a lens that can zoom from around 18-55 mm (29-88 mm equivalent on an APS-C sized sensor). But before you jump at this low-cost lens solution, you've got to realize one thing—that small maximum aperture *will* limit your creativity.

The simple reason for this is that a wide aperture lens can create images that just aren't possible any other way, and when you start shooting "wide open" you're immediately going to be taking pictures that are different than most other people's. For example, you could get 100 photographers together in one place and they could all take a picture of the same scene at f/8, but how many could take the shot at f/1.8? Or f/1.2?

Despite noting that wide-aperture lenses are, as a rule, expensive, some are still most definitely affordable. For example, Canon's 50 mm f/1.8 is around $115 at the time of writing, while Nikon's 50 mm f/1.8 is about the same price. Given the benefits these lenses can bring to your photography in terms of their widest aperture setting, this already makes them a bargain, but if you're willing to put up with their idiosyncrasies, better value still can come from older, manual focus lenses—those "legacy" lenses that were once attached to film SLRs, but now find themselves in rummage sales or gathering dust on camera dealers' shelves.

right: Olympus E-510, 50 mm lens with 2x teleconverter. 1/45 sec. f/8, ISO 100

A fast, 50 mm manual focus standard lens will typically focus closer than a contemporary zoom lens, making for a high-quality, low-cost close-up solution.

Legacy lenses

Maybe 20 years ago, if you bought a 35 mm SLR the chances
are it would have come with a manual focus, 50 mm fixed
focal length lens—universally known as a "standard lens."
While this didn't have the versatility of a zoom, or indeed
the advanced computer-aided design of modern lenses, it
did have one major advantage—most of these lenses had
a fast, f/1.8 aperture, while some boasted f/1.4 or even f/1.2
maximum apertures.

The good news for photographers buying digital SLRs today
is that a number of camera manufacturers are still using
the same basic lens mount they used on their film SLR
cameras. Although the sophistication of the mount has
evolved to accommodate advanced autofocus systems and
provide increased communication between the camera body
and the lens, the bayonet fitting has remained the same,
which means many older lenses will fit—and work—on a
modern digital SLR.

Nikon and Pentax digital SLRs, as well as those from Fuji
and Samsung (which use the Nikon F and Pentax K lens
mount, respectively) offer the easiest solution, as manual
focus legacy lenses with the relevant mount will fit straight
on to a digital SLR. Other manufacturers provide backward
compatibility through lens adapters, such as the adapters
that let you mount Olympus OM or Leica R lenses on a Four
Thirds digital SLR, for example.

Unfortunately, things are a little less positive when it comes
to two of the leading digital SLR makers: Canon and Sony.
While there are adapters available that will let their digital
SLRs take older Canon FD and Minolta lenses (the precursor
to Sony), the cost of the adapters largely negates the benefit,
so you may as well invest in a modern, wide aperture, fixed
focal length lens to start with.

Which legacy lenses?

It's impossible to give a detailed list of which lenses work best with which cameras, and it's equally futile to work on the basis that if a lens is good on a 35 mm film SLR it will work well on a digital SLR—sometimes, and for no obvious reason, this is not the case.

However, a great starting point is a 50 mm, f/1.8 prime lens from a "known" manufacturer. For as little as $10 you can get yourself a great lens with a wide aperture that is capable of producing a very shallow depth of field. Not only that, but the magnification factor on an APS-C–sized sensor means the lens will have an effective focal length of around 80 mm—perfect for portraits.

Modest telephotos also have their advantages, not least because the focal length will be extended by a factor of 1.5x or 1.6x on an APS-C–sized sensor (2x on a Four Thirds camera). As a result, a 200 mm f/4 lens would behave like a 300-400 mm lens (depending on the sensor size), which is a great solution for "slow moving" wildlife such as birds perched at a distance, or animals visiting a watering hole on a safari, for example. Plus, the cost will be a fraction of a modern lens covering the same focal length and aperture.

At the same time, though, it is generally a good idea to stay away from focal lengths of 24 mm or shorter as these are likely to introduce unwanted artifacts at the edges of the frame. Manual zoom lenses are also best avoided—you generally do not gain any advantage in terms of the maximum aperture, and there are usually image quality issues as well. Zoom technology has come a long way since.

opposite: Fuji FinePix S5 Pro, 90 mm macro lens, 1/125 sec, f/2.8, ISO 3200

Dedicated macro lenses are usually expensive, but the 90 mm Tamron SP lens used for this shot cost less than $50—a bargain considering its f/2.5 maximum aperture.

above: The 50 mm lens is the "standard" for 35 mm SLRs, and often has a fast f/1.8 aperture. Best of all, both manual and autofocus lenses can be bought for very little.

below: Nikon and Pentax owners can mount legacy lenses straight onto their digital SLRs, but with Four Thirds digital SLRs like this Olympus, you need an adaptor.

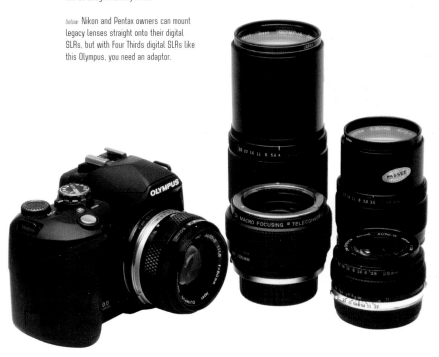

Using legacy lenses

Although legacy lenses will fit your digital SLR, it's important to understand that using a manual focus lens that was developed in a pre-digital world is not going to be as simple as fitting the lens, pointing the camera, and taking a shot. Obviously, you will have to focus the lens manually, but this is just one of the problems you are likely to encounter. In some instances, the camera's exposure metering system might behave erratically, producing some shots that are correctly exposed, and others that are not. Alternatively, depending on your camera, it simply will not work at all. Assuming it does work, it's highly likely that you'll have to manually set the aperture you want to use on the lens, at which point the darkened viewfinder will make it harder to focus. Also, you might experience disappointingly poor results at some aperture settings, with sharpness falling off toward the edges of the frame, increased color fringing (chromatic aberration), and vignetting.

Yet while it might sound like there are a lot of reasons not to consider using legacy lenses, there are equally good reasons why you should. First off, a fixed focal length lens is much easier to optimize than a zoom, so a prime lens is a fundamentally superior design when it comes to achieving the best quality image. Also, if you are using a digital SLR with a non full-frame sensor (APS or Four Thirds) then you will only be using the center of the lens's imaging circle. This is critical, as the center of a lens is, optically speaking, the best part of the lens—it's the edges that are responsible for most unwanted artifacts. So, with a legacy lens, you are potentially using the best part of a superior lens design, which means a manual focus, 50 mm, f/1.8 lens costing $5 in a yard sale can actually produce sharper images than a modern budget zoom lens covering the same focal length. Not only that, but you can take advantage of the wider apertures offered by these lenses to create shallow depth of field effects that are simply impossible to achieve with most zooms, unless you spend a small fortune.

left: The imaging circle of legacy lenses is designed to cover a 35 mm film frame — the same area as a full frame digital sensor. If your camera uses a smaller sensor, such as an APS-C sized chip, then only the central part of the lens is used to form an image. In terms of image quality, the middle of any lens is always superior to the edges, where there is an increased risk of light fall-off (vignetting), fringing (chromatic aberration), or a lack of sharpness.

right: Olympus E-500, 50 mm lens with macro bellows. 1/2 sec. f/4, ISO 200

There's noticeable cyan fringing around the stamen of this flower, which is a common problem with some, but not all, legacy lenses. Using a different aperture setting can remedy this in some instances, or you simply have to accept it as an unavoidable lens-based artifact.

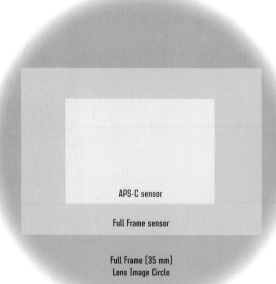

APS-C sensor

Full Frame sensor

Full Frame (35 mm)
Lens Image Circle

Using shallow depth of field

Many photographs are esthetically stronger when only a portion of the image is in focus: for example, a portrait where only the subject's eyes are sharply defined, or a single flower isolated against its background to focus the viewer's attention. The key to success comes from precise control over the depth of field, which is determined by three main factors: the size of the aperture, the focal length of the lens, and the camera-to-subject distance.

Wider apertures naturally have a shallower depth of field, but to illustrate precisely what effect they have, imagine you are shooting a portrait using a 50 mm, f/1.8 lens, with your model standing 6 1/2 feet (2 m) from the camera. With the aperture set to f/5.6, the depth of field in this scenario would extend from 5' 9" to 7' 7" (1.76 m to 2.31 m), so it will cover 22 inches (55 cm). However, if you opened the lens up to its maximum aperture setting of f/1.8, the depth of field would immediately be reduced to just 7 inches (17 cm).

You can also change the depth of field by using a longer focal length, as wide-angle lenses produce images with an apparently greater depth of field. Zooming in from a distance with a telephoto lens is a great way of reducing the zone of sharpness in an image, especially if you combine this with a wide aperture.

Finally, if you really want to restrict the depth of field, you can decrease the camera-to-subject distance. Using the portrait example above, if you reduced the distance between the camera and subject so the subject was 3 feet (1 m) away, the depth of field becomes a lot shallower. At f/5.6 it would cover 5 inches (13 cm), while opening the aperture to f/1.8 would give a depth of field covering just 1 1/2 inches (4 cm).

left: **Canon EOS 5D, 17-40 mm zoom @ 40 mm, 1/2000 sec, f/4, ISO 100**

A still life image, taken outdoors. The shallow depth of field prevents the background from detracting from the subject.

DEPTH OF FIELD TOOLS

With practice you will find that you develop a good grasp of depth of field, but there are many tools that are available that will calculate the precise depth of field for you. For example, I use PhotoCalc— an iPhone and iPod app— although there are numerous online calculators.

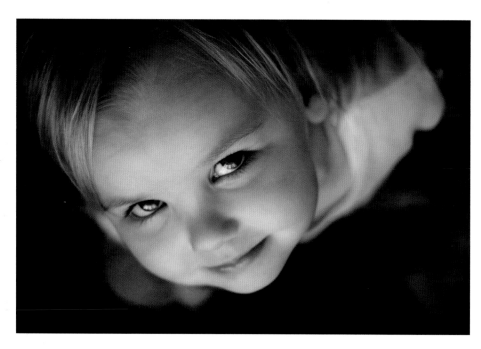

left Canon EOS 20D, 50 mm lens, 1/100 sec, f/1.8, ISO 100

Choosing the point of focus needs to be carefully considered when you're using a wide aperture. For this portrait, I chose to focus on the eye closest to the camera.

right Canon PowerShot G5, 1/80 sec, f/3.0, ISO 50

For this flower study I took a selection of shots, focusing at different points in the frame. It is much easier to choose one when you can see them on a computer screen than trying to assess depth of field on your camera's LCD screen.

As this suggests, simply using a wide aperture is not the only way to obtain a limited depth of field—if you want as little of the subject in focus as possible, the best combination is a wide aperture setting on a lens with a long focal length, with the subject placed close to the camera.

Yet while the technical considerations are reasonably straightforward, the one thing to remember is that your focusing must be extremely accurate. If you are shooting a static object this isn't a major problem—you can take your time, assess your images, and reshoot if necessary—but when you are photographing something that might move at the moment you make the exposure you need to be far more careful. To be sure you get a sharp image in these situations, it is often best to either set a slightly smaller aperture and accept a slight increase to the depth of field, or consider taking a sequence of shots so you increase the chance of getting one with perfect sharpness.

In addition to the technical and shooting issues, there are a number of esthetic considerations when you are shooting with a shallow depth of field. When a shot contains a single element that you want to isolate from its background, focusing is relatively straightforward, but when there is more than one element in a shot things become more difficult. For example, if you are shooting a portrait and the person is angled away from the camera, should you focus on the eye that's closest to the camera, their nose, or the eye farthest from the camera? Likewise, if you are shooting flowers from above, do you focus on the nearest one, the one in the middle, or one farthest from the camera? There is no single answer to this, and like many esthetic decisions, you should focus on the area of the image that *you* feel will give the final image most impact. If you aren't sure, try shooting a selection of images using different points of focus, and then pick the one you prefer when you review them at a larger size on your computer screen.

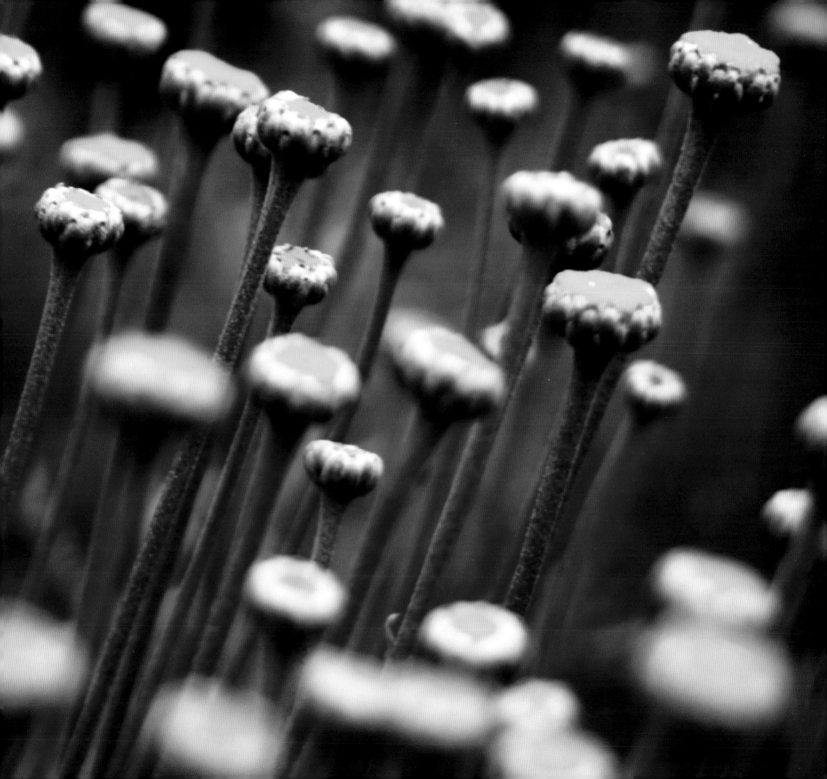

left: Canon EOS 20D, 70-200 mm @ 126 mm, 1/640 sec, f/5.6, ISO 100

Choosing the point of focus is critical. Here, the grasses would have been unrecognizable if they were blurred, but the distant boat remains identifiable, despite being heavily out of focus.

How shallow should the depth of field be?

While it's often tempting to shoot an image with as small a depth of field as possible, this isn't always desirable. If you shoot "wide open" (at the widest aperture setting) the depth of field will be minimal, but the edges of the subject can become soft and start to merge into the background. So, if you are attempting to isolate an object from its background, it can often be better to set a slightly smaller aperture to make sure that all of the subject is in focus and the edges really stand out against the softer background, rather than shooting wide open. In these circumstances it's a good idea to shoot a range of shots in Aperture Priority or Manual mode, working up from the widest aperture setting by two stops (f/2.8, f/4, and f/5.6, for example) and deciding which one works best when you see them on your computer.

It's also worth reiterating that it's not just the aperture that controls depth of field—subject distance and the focal length of the lens are also crucial. To take an extreme example, if you are shooting with a 100 mm macro lens, and the object is very close to the camera, you will find that you actually need a very *small* aperture to obtain anything other than a razor-thin depth of field. Even at the smallest aperture that such a lens can provide—f/22, say—the depth of field will still be relatively shallow, so be prepared to use a smaller aperture than you might anticipate with longer focal length lens, or a short camera-to-subject distance.

Ultimately, shooting an image with a shallow depth of field is definitely challenging. Not only do you need to decide what to focus on, but you also need to consider how much of the focused element should be sharply defined, and how blurred the background should be in relation to the remainder of the image. However, from an esthetic point of view, wide aperture shots often have considerable visual impact and provide much greater scope for you to creatively control the content and appearance of your photographs.

left: Canon EOS 1Ds Mark II, 70-200 mm zoom @ 200 mm, 1/250 sec, f/4, ISO 100

For this enchanting portrait, a wide aperture with a long focal length focuses attention on a narrow band across the center of the frame.

Bokeh

Bokeh is a term derived from the Japanese word for blur or haze, which refers specifically to the nature of the out-of-focus areas in an image, particularly out-of-focus point-light sources. It is increasingly common to hear photographers discussing bokeh, often describing it as "good" or "bad," as though it's something you can specifically control, but you cannot—the effect is caused by the shape of the lens aperture, the physical design of the lens, and the extent to which the lens is corrected for spherical aberration. In short, the lens creates the bokeh, not the photographer.

Bokeh and aperture shape

When you shoot at anything other than the lens's widest aperture setting, any out of focus points in the image will take on the shape of the iris—the physical shape of the aperture the light is passing through. With some lenses, especially those with a high number of aperture blades, this results in the brighter areas within defocused parts of the image appearing as diffuse circles. However, most lenses have fewer blades in the aperture, which leads to polygonal irises, resulting in point sources of light in out of focus areas taking on the same multi-sided shape.

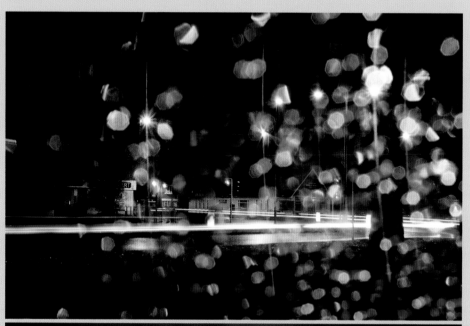

top to bottom:
Canon EOS 20D, Canon EF 17-40 mm
f/4 L zoom, 30 secs, f/4, ISO 100

Canon EOS 1Ds Mk II, Canon EF 70-200 mm
f/2.8 L zoom, 1/80 sec, f/3.5, ISO 200

Taken on two different lenses, the bokeh in these shots reveals different characteristics. In the night scene, the out of focus highlights appear as polygons, while the outdoor portrait exhibits much smoother, almost circular bokeh. This is primarily due to the number of aperture blades—7 in the lens used for the night shot and 8 in the lens used for the portrait.

How lens design affects bokeh

Although the shape of the aperture has an effect on the bokeh shape, the design of the lens also has an impact. The most obvious example is a catadioptric, or "mirror" lens. Unlike a conventional (rectilinear) lens, light doesn't simply travel through what is effectively a tube containing glass elements. Instead, a catadioptric lens has a mirror in the center of the front element (hence the name "mirror lens"), which faces the camera's sensor. Light enters the lens around this mirror (heading toward the sensor), is reflected off a second mirror at the rear of the lens, strikes the rearward facing mirror at the front, and is finally reflected back toward the sensor.

So how does this affect the bokeh? Well, because the mirror behind the front lens element blocks the central portion of the optical path, light enters the lens in a "ring" shape. This effectively becomes the shape of the lens's aperture, resulting in very distinct, ring-shaped bokeh.

Spherical aberrations and bokeh

A spherical aberration is an optical effect caused by the bending of the light rays as they travel through the lens, and it largely depends on whether the light travels through the edge or center of a particular element within a lens. A lens that is very well corrected for spherical aberrations will produce evenly illuminated bokeh, while a lens that is less well corrected may produce bokeh that is brighter in the center of the image than it is at the edges, or vice versa. Yet while different lenses will produce different forms of bokeh, evaluating the merit of different types is a purely subjective call—there are no objective criteria that can be used to say that one form of bokeh is better or worse than another.

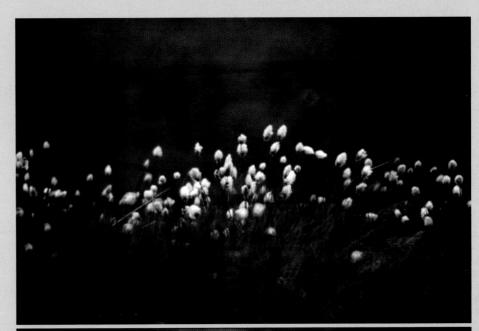

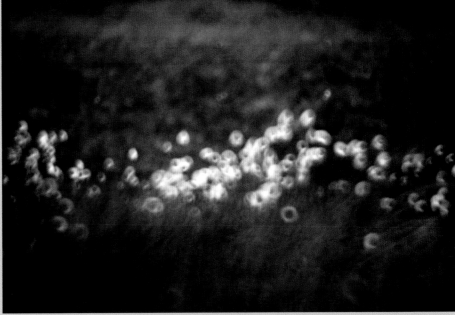

Canon Digital Rebel, 500 mm mirror lens, 1/100 sec, f/8, ISO 400

In and out of focus: the tell-tale doughnut-shaped bokeh of a catadioptric (mirror) lens.

Tilt and shift lenses: Minimizing depth of field

We've already seen how conventional photographic lenses can be used to minimize depth of field, but there are other lenses that are also worthy of note in this regard; most notably, tilt and shift lenses.

Unlike conventional photographic lenses, where the optical path is fixed and light travels through the lens elements in a straight line, tilt and shift lenses let you modify the direction that the light takes. In architectural photography, the shift function is the more significant of the two, as it helps photographers avoid converging verticals so buildings remain upright, and walls remain parallel. However, in the context of ultra-wide apertures, the shift movement is fairly redundant as it only alters the perspective of an image and has no effect on depth of field.

Tilting, on the other hand, involves changing the plane of focus in relation to the film or sensor plane. There are two primary forms that this tilt can take—backward or forward. Tilting the lens backward is what we're most interested in here, as this movement will alter the plane of focus in such

a way that the depth of field in an image appears to decrease at any given aperture.

As the accompanying illustrations show, because the lens is no longer focusing parallel to the sensor, the resulting picture will show a much narrower band of focus. Although the depth of field has not physically changed, its direction—and therefore its appearance—has, and the greater the backward tilt, the greater the effect. If a backward tilt is used in conjunction with a wide aperture, you can produce an image with only the tiniest sliver of sharpness across it, or you can use a smaller aperture to produce a selective focus effect. Either way, a tilt action can convert a wide aperture effect with a shallow depth of field into an ultra-wide aperture effect, with an ultra-shallow area of sharpness.

A tilt and shift lens, such as this 85 mm Nikkor, is ideal for controlling the apparent size and direction of the depth of field.

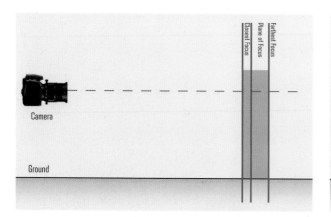

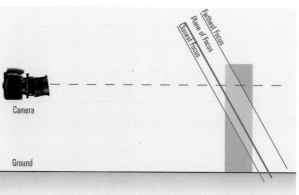

As these illustrations demonstrate, applying a tilt with a tilt and shift lens has no effect on the actual depth of field — it covers the same distance at any given aperture. However, the tilt does change the plane of focus. Here, a backward tilt would mean that instead of the entire block being in focus (far left), only the top of the front face would be sharp, giving a "selective focus," or ultra-wide aperture look.

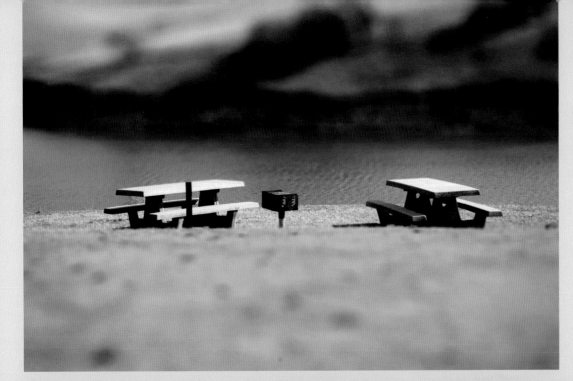

left: **Canon EOS Digital Rebel XT, 35 mm tilt & shift lens, 1/350 sec, f/5.6, ISO 1600**

Narrowing the depth of field with a tilt and shift lens makes this shot far more interesting than it would be if everything was in focus.

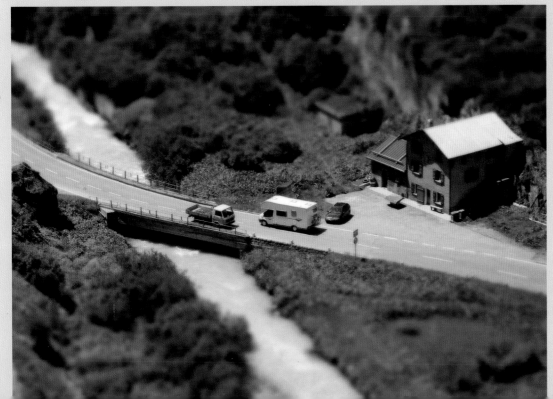

left: **Canon EOS 5D, 90 mm tilt & shift lens, 1/400 sec, f/8, ISO 125**

Adjusting the plane of focus gives an added dimension, as the narrow zone of sharpness runs at a slight diagonal across the frame.

left: The Lensbaby line up (left to right): Composer, Control Freak, and Muse.

The Lensbaby

The Lensbaby has been around for a good few years now, and from its humble origins there are now three different models: the Composer, Control Freak, and Muse. Each lens operates in a similar way to a tilt and shift lens, allowing you to move the front of the lens relative to the film plane. However, a Lensbaby costs much less than a tilt and shift lens, and works in a slightly different way. Rather than changing a linear plane of focus, altering the position of the Lensbaby lens causes its "sweet spot"—a central area of sharpness—to move to different areas of the image. This sweet spot is surrounded by an area of blur, and the farther from the sweet spot, the blurrier the image becomes.

The Lensbaby range is entirely manual, both in terms of focusing and varying the aperture, which is achieved by dropping an aperture ring into the lens mechanism. The aperture can be varied from f/2 to f/22, but unlike a conventional lens a wider aperture doesn't give a shallower depth of field—instead, it produces a smaller sweet spot.

opposite: Canon EOS 20D, Lensbaby Muse, 1/8 sec, f/2.0, ISO 100
Unlike a conventional lens, a Lensbaby produces a circle of relative sharpness known as the "sweet spot." Everything outside the sweet spot drifts off into a blur.

above: Nikon D200, Lensbaby Composer, 1/50 sec, f/4, ISO 100
A Lensbaby is ideal for isolating a subject from its background. Using a wide aperture creates a smaller sweet spot, while smaller apertures give a larger circle of sharpness.

Not everything has to be sharp

There are a multitude of ways in which the quality of a photograph can be assessed, but one of the most common questions asked of photographs is "is it sharp enough?" By this, we mean are the right areas of the image in focus, and are they clearly defined? Often, the answer will be no (on one or both counts) and we will reject the image and move on. But should we?

As we've already seen, one of the easiest ways of reducing the overall sharpness in an image is to shoot with an ultra-wide aperture to limit the depth of field. This is incredibly effective at isolating a subject from its background, and we've seen how a wide aperture or specialist lens can be used to create striking images. But why stop at having a small portion of the image in focus? Why not take the conventional idea of image sharpness, turn it on its head, and set out to produce deliberately "soft" images instead?

Defocusing

The simplest way of achieving this is to intentionally "defocus" the image—just switch your camera from autofocus to manual focus and you can adjust the point of focus so that nothing is sharp. The risk here is that the final photograph will look more like a mistake than an intentional act on your part, but in some cases it can be an effective technique, especially with point sources of light or when your aim is to create an image that is more about an overall mood than it is about detail.

right: Canon EOS 5D, 70-200 mm zoom @ 105 mm, 1/100 sec, f/4, ISO 400

Some images don't need to be in focus at all. You can still "read" this image as a neon-lit city street, even though nothing is sharp. The reduction of the picture to colored shapes eliminates any distractions and makes the shot far more evocative.

Canon EOS 5D with 70-200 mm zoom @ 200 mm, 1/25 sec,
f/2.8, ISO 100

Deliberately allowing some parts of an image to blur can help you
isolate a specific part of the picture, drawing the viewer into the scene.

Soft-focus

Unlike defocusing, soft-focus is about taking the edge off an image's sharpness, rather than producing a completely blurred result. This is a technique that is often used by portrait photographers to add a "dreamy," diffuse feel to an image and hide any imperfections in skin tone and texture.

There are a number of ways to achieve a soft-focus effect—either when the shot is taken, or later, during post-production. The most expensive method is to purchase a dedicated soft-focus lens to use on your camera, but these are few and far between, and those that do exist are very expensive. A more affordable method is to use a soft-focus filter in front of a conventional lens. These are made by a number of companies, and come in a variety of strengths. An alternative—and far more popular—approach is to opt for a "home-made" solution, either by stretching a nylon stocking over the front of the lens (a popular technique with fashion photographers), or the rather messier option of smearing a clear filter with Vaseline. Both techniques work, but control over the result can be limited.

However, although in-camera soft-focus is possible, it is reasonably straightforward to add a similar effect during post-production, and working in this way gives you more control over the resulting level—and position—of any diffusion. One of the easiest ways to do this is to duplicate an image so it is copied as a new layer, and then apply a small amount of blur to the duplicated layer. You can then reduce the opacity of the blurred layer so the original, sharper image shows through the blur to a lesser or greater degree. Alternatively, you can change the blending mode of the new layer if your image-editing software has this feature. In Photoshop and Photoshop Elements, for example, changing the blurred layer's blending mode to Soft Light will produce a moderate soft-focus effect, while Overlay will create a stronger effect. The added advantage of working digitally is that if the effect is too strong, you can reduce its intensity, or simply start over.

To create the soft, dreamy feel in this portrait I added a soft-focus effect in Photoshop. I did this by duplicating the image, blurring the duplicate layer, and then blending it with the original, sharp image.

5. ULTRA-SMALL APERTURES

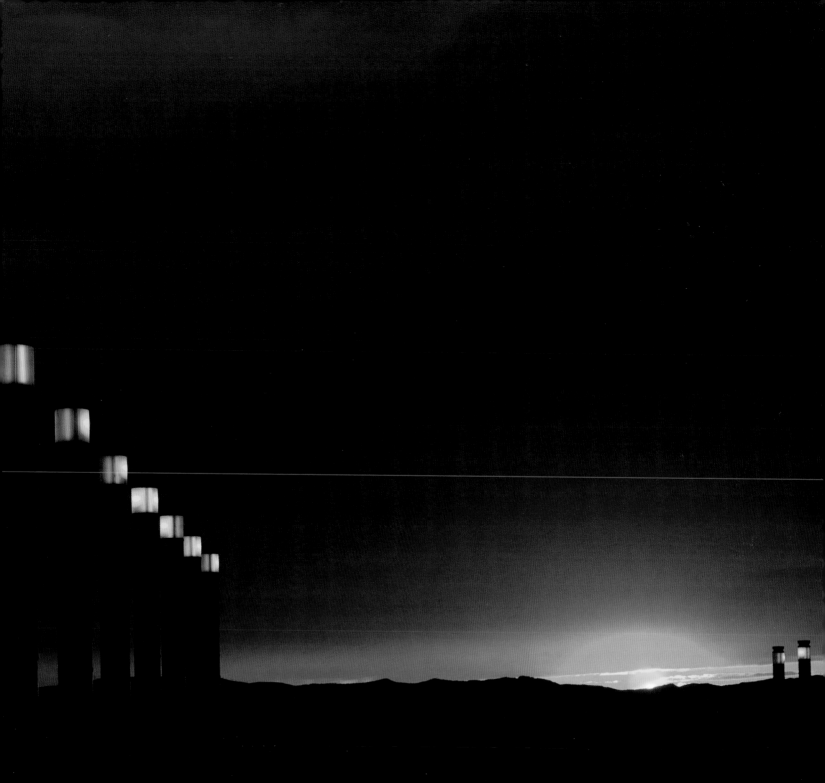

Maximizing depth of field

One of the main uses of a small aperture is to get a greater depth of field, a technique commonly employed by landscape and architectural photographers who want to record every detail, from the foreground right through to the horizon. But simply setting a small aperture is not enough—to maximize the depth of field in an image you also need to set the hyperfocal distance.

The first thing to understand is that depth of field doesn't extend equally from the focal point. Instead, it extends approximately 1/3 in front of the focal point (toward the camera) and 2/3 beyond the focal point (away from the camera). If you focus on infinity to record a distant subject this means you are losing a massive 2/3 of the potential depth of field at whatever aperture you are using, simply because the lens cannot focus beyond infinity. So, to maximize the depth of field you need to set the lens to a closer focal point.

The optimum point of focus is the hyperfocal distance—the point at which you focus to achieve the maximum depth of field at any given aperture. Usually, when you set the hyperfocal distance, infinity will be the most distant part of the image that's in focus, while the closest point that will also be sharp is half of the hyperfocal distance. So, if the hyperfocal distance for a certain lens/aperture combination is 30 feet (9.1 m), focusing at that distance would mean everything from 15 feet (4.55 m) to infinity appears sharp.

Calculating the hyperfocal distance

Because the hyperfocal distance is determined by the combination of focal length and aperture, it is impossible to give every permutation here. There are equations you can use to calculate the hyperfocal distance for each lens and aperture combination, but by far the easiest method is to use an online calculator, such as www.dofmaster.com.

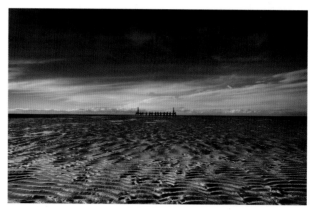

left: **Canon EOS 1Ds Mark II, 17-40 mm zoom @ 17 mm, 1/500 sec, f/8, ISO 100**

Using a 17 mm focal length and an aperture of f/8, the hyperfocal distance for this shot is 4 feet (1.2 m). Focusing on this point ensures that everything in the image is in focus, from the sand in the foreground to the structure in the distance.

opposite: **Canon EOS 1Ds Mark II, 20 mm lens, seven bracketed exposures, f/8, ISO 100**

An HDR image constructed from seven exposures made at f/8. The aperture setting, combined with a wide-angle lens is sufficient to keep everything in the frame in focus.

This is one of many applications that are available for desktop computers or handheld devices such as iPhones and the iPod Touch, and it will also take into account any focal length magnification that applies if you are using a digital SLR with an APS-C or Four Thirds sized sensor.

However, while it is possible to calculate the hyperfocal distance for any lens/aperture combination, setting this in the field can be problematic. Why? Well, despite the advances in digital technology, many manufacturers no longer have a focus distance scale on their lenses (especially on lower end zoom lenses), and even if a lens does have a focus scale marked on it, it will only show a certain range of values. For example, the scale on my Canon 35 mm f/1.4 lens (a lens that happens to be on my desk as I'm writing this) has (metric) distances of 0.3 m, 0.35 m, 0.4 m, 0.5 m, 0.7 m, 1 m, 3 m, and infinity marked on it. This is a useful guide, but if I want to use an aperture setting of f/16, the hyperfocal distance would be 2.59 m (8 ½ feet), which isn't a distance that is marked on the lens. This means there would be some guesswork involved in setting the hyperfocal distance precisely, although manually focusing the lens to the 3 m mark would be close, and certainly better than simply focusing on infinity.

Tilt and shift lenses: Maximizing depth of field

In the previous chapter we looked at how a tilt and shift lens can be used to change the plane of focus and give the appearance of a reduced depth of field with a wide aperture. However, by tilting a lens forward, and using a small aperture, the opposite happens: The depth of field appears to be extended. This is known as the Scheimpflug principle, first referenced by Theodor Scheimpflug in a 1904 British patent, and it forms the basis of a useful technique that was—and still is—widely used by landscape and studio photographers shooting with large-format cameras.

Maximizing the optical quality of your images

The obvious use for this technique is to combine lens tilt with the smallest aperture available, so you get an even greater depth of field than this small aperture setting offers. This is a perfectly reasonable approach, but you can also use a tilt lens to enhance image quality. All lenses have one aperture setting that will produce the sharpest results, and this is typically "two stops down," as in two stops down from the smallest aperture. In practice, this means most lenses will produce their sharpest images at f/8 or f/11.

Although the depth of field at f/8 is less than it is at f/16 or f/22, tilting a tilt and shift lens forward will increase the apparent depth of field. As a result, you can use the optimum aperture setting (for sharpness), while still producing an image with a large depth of field.

Tilt and shift lenses also offer a benefit when it comes to controlling the shutter speed. Small apertures, such as f/22, may let you maximize depth of field, but they also require longer shutter speeds. If you are shooting a static scene, the shutter speed is largely irrelevant, but if you're shooting a scene containing some form of movement it can be more crucial. Say, for example, you were shooting on an overcast day and the fastest shutter speed you could obtain at f/22 was 1/8 sec. By using an aperture of f/8 and tilting the lens you would achieve a similar depth of field, but you would be able to use a shutter speed three stops faster (the difference between f/8 and f/22), so in this example, you could take the same shot at 1/60 sec. Not only would this help freeze any movement, but you would also be shooting at the lens's optimum sharpness setting for the best of all worlds!

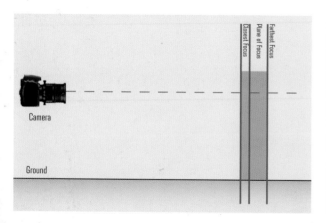

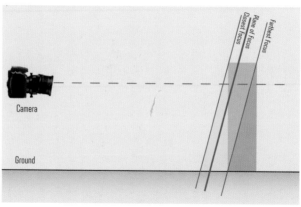

left: Based on the Scheimpflug principle, tilting a lens forward gives an apparent increase in the depth of field. This technique lets you extend the depth of field at the lens's maximum aperture so you get a greater zone of sharpness, or you can use the lens's optimum aperture setting without losing depth of field.

opposite: **Canon EOS 1Ds Mark II, 24 mm tilt and shift lens, 1/80 sec, f/8, ISO 100**

Tilting the lens forward and setting the aperture to f/8 means the immediate foreground is sharply defined, as well as the horizon, and the shot has been taken at the lens's optimum aperture.

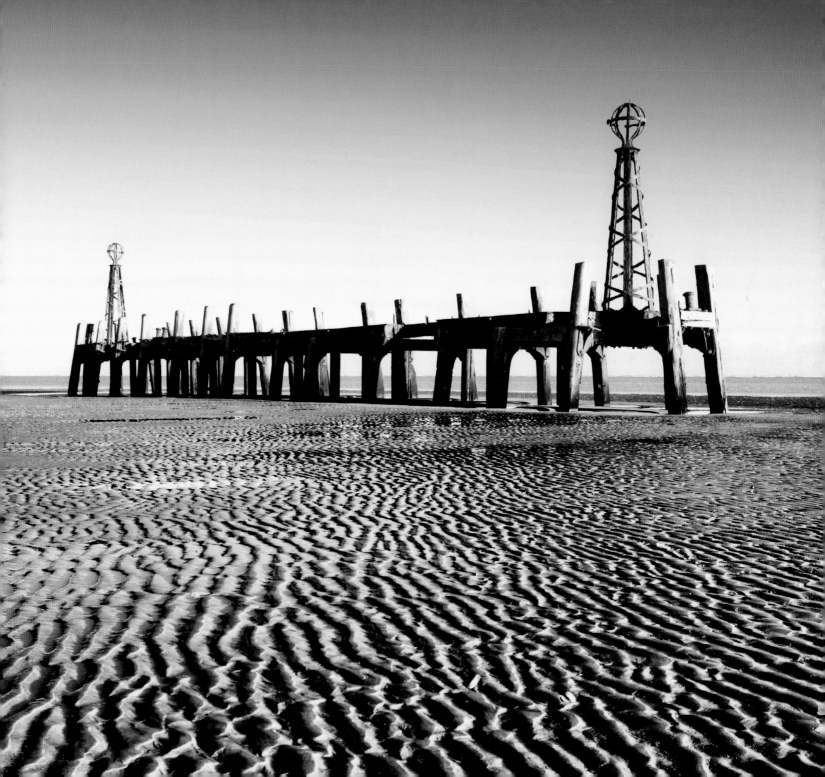

Focus stacking

The closer you focus to the camera, the shallower your depth of field becomes and with macro photography this can mean the depth of field may only cover an inch at the smallest aperture setting. However, there is a way that you can work around this common problem, using a software-based solution known as "focus stacking."

Just as HDR photographs are constructed by shooting a range of exposures, so focus stacking also starts with a sequence of images. However, instead of the exposure changing from shot to shot, the point of focus is changed. The sequence is then combined—or "stacked"—to create a final result that uses the sharp, in-focus elements of each picture to create the effect of a much larger depth of field.

There are a number of benefits to this approach, not least that you can create images that are simply not possible with a conventional lens, even when shooting using its smallest aperture. You can also maximize the quality of the final image by shooting at your lens's optimum aperture, and this also means you can shoot a sequence of images using a faster shutter speed, rather than a single, long exposure that might increase noise.

SINGLE SHOT

Taken using an aperture setting of f/32—the smallest aperture available on my Canon 100 mm macro lens—the front of the bracelet is sharp, but the focus falls off toward the rear of the image.

STACKED IMAGE

For this picture, a sequence of images were taken at an aperture setting of f/11—the lens's optimum aperture. Focusing at different points and then "stacking" the images creates a much greater depth of field, and the entire bracelet is now sharply focused.

How to focus stack

The shot of the bracelet shown here was constructed using Helicon Focus (www.heliconsoft.com), an affordable program for both Mac and PC. But before you can stack your images you need to shoot them, and there are three things you should bear in mind. First, you should aim to keep your camera as steady as possible between exposures, so it's a good idea to use a tripod and remote release. Second, you should start with either the near point or the far point of focus, and work to the opposite extreme—don't start in the middle. Finally, and most importantly, you should aim to shoot enough images so that each part of the subject is sharp in at least one of the photographs. There will be some guesswork involved in this as it's difficult to judge the depth of field in each shot as you take your sequence. If you are in any doubt, shoot more images than you think you will need. For this bracelet image, six photographs taken at f/11 were enough to ensure every part of the bracelet was sharp in at least one of the frames.

Once you have shot your sequence of images you can import them into Helicon Focus using the "Add Images" button, or the File menu (*File>Add Images*). You can then combine them using *Tools>Render* and if the original sequence doesn't pose any problems for the software, you're done—all you need to do is click Save!

ORIGINAL SEQUENCE

The six shots used to create the final bracelet image were all taken with an aperture of f/11. The point of focus was changed for each shot, allowing some overlap so, when the images were stacked, the whole bracelet would appear sharply focused.

Focus parameters

If your initial render is less than perfect, there are three focus parameters in Helicon Focus that might help improve the final result. The first of these is the Render Method. Method A (Weighted Average) calculates the contrast of each pixel, while Method B (Depth Map) creates a depth map based on the sharpest pixels within one of the images. Generally, both of these work equally well, with little, if nothing, to tell them apart. However, if one produces a poor result, it is worth trying the other.

The second change you can make is to the Radius. The default value normally produces good results, but images with fine detail can benefit from a lower setting (a value of 3-6), while images with more coarse detail might require a higher setting (a value of 10-15).

Finally, you can adjust the Smoothing, which determines how the data from the images is combined. A low level can increase sharpness (but introduce artifacts) in the final picture, while a higher value will give a more seamless result, but with the possibility of some additional blur.

The limitations of focus stacking

While focus stacking works well with motionless subjects, it will struggle when parts of a scene move between frames—a landscape that contains trees or flowers blowing in the wind, or water, for example. Combining the initial sequence can be much harder and in some cases it is simply impossible to achieve the desired result without heavy cloning in an image-editing program.

Focus stacking software can also struggle when there are abrupt transitions in the plane of focus, such as a greater distance between the foreground and background elements. The reason for this is there is always a slight shift in the *size* of in-focus and out-of-focus elements in an image, and the greater the distance between the elements, the greater the size difference. This can mean that a defocused element in one shot appears larger in the frame than it does when it is sharply in focus in another frame. As the above illustration shows, this can create an unusual blurred edge when the image sequence is stacked.

above: The pole changed size depending on whether it was in or out of focus in this shot. As a result, the right edge exhibits a blurring artifact when the focus sequence is combined.

opposite: **Fuchsia dewdrop refraction.**

The initial sequence for this shot consisted of 10 images, taken at f/7.1. Focus stacking was necessary to get all of the water drops in clean focus, but more importantly it also means all the flower refractions inside the drops are in focus as well.

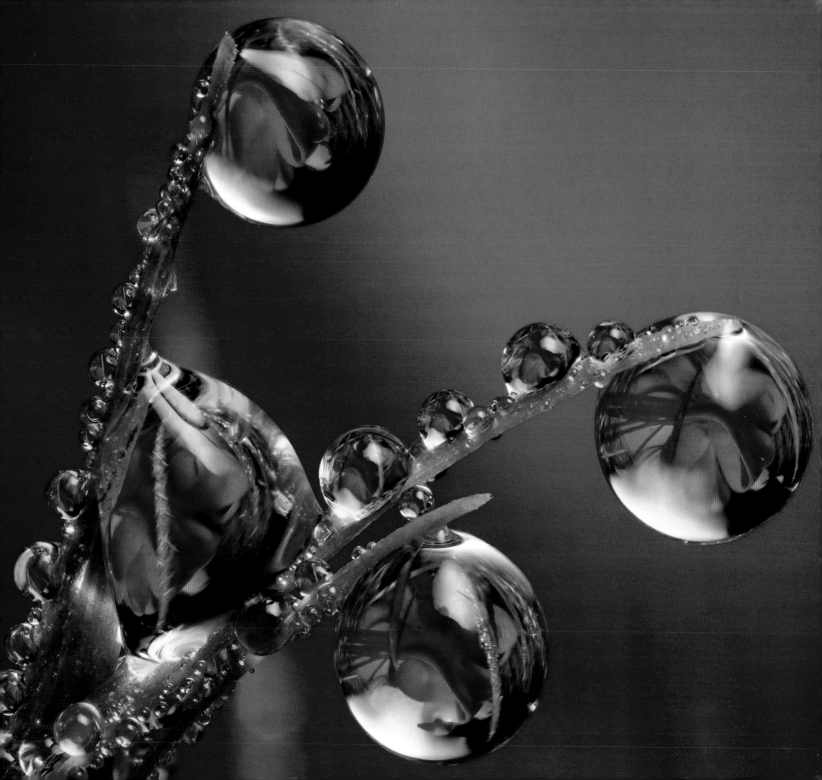

REFERENCE

Glossary

aperture The opening behind the camera lens through which light passes on its way to the image sensor (CCD/CMOS).

artifact A flaw in a digital image.

bit (binary digit) The smallest data unit of binary computing, being a single 1 or 0.

bit depth The number of bits of color data for each pixel in a digital image. A photographic-quality image needs 8 bits for each of the red, green, and blue channels, making for a bit depth of 24.

bracketing A method of ensuring a correctly exposed photograph by taking three shots; one with the supposed correct exposure, one slightly underexposed, and one slightly overexposed.

CCD (Charge-Coupled Device) A tiny photocell used to convert light into an electronic signal. Used in densely packed arrays, CCDs are the recording medium in some digital cameras.

channel Part of an image as stored in the computer; similar to a layer. Commonly, a color image will have a channel allocated to each primary color (e.g., RGB) and sometimes one or more for a mask or other effects.

CMOS (Complementary Metal-Oxide Semiconductor) An alternative sensor technology to the CCD, CMOS chips are used in an increasing number of digital cameras.

CMYK (Cyan, Magenta, Yellow, Key) The four process colors used for printing, including black (key).

color gamut The range of color that can be produced by an output device, such as a printer, a monitor, or a film recorder.

color temperature A way of describing the color differences in light, measured in Kelvin and using a scale that ranges from dull red (1900 K), through orange, to yellow, white, and blue (10,000 K).

contrast The range of tones across an image, from bright highlights to dark shadows.

cropping The process of removing unwanted areas of an image, leaving behind the most significant elements.

depth of field The distance in front of and behind the point of focus in a photograph, in which the scene remains in acceptable sharp focus.

file format The method of writing and storing information (such as an image) in digital form. Formats commonly used for photographs include TIFF, BMP, and JPEG.

fill-in flash A technique that uses the on-camera flash or an external flash in combination with natural or ambient light to reveal detail in the scene and reduce shadows.

focal length The distance between the optical center of a lens and its point of focus when the lens is focused on infinity.

f-stop The calibration of the aperture size of a photographic lens.

grayscale An image made up of a sequential series of 256 gray tones, covering the entire gamut between black and white.

HDRI (High Dynamic Range Imaging) A method of combining digital images taken at different exposures to draw detail from areas which would traditionally have been over- or under-exposed. This effect is typically achieved using a Photoshop plugin, and HDRI images can contain significantly more information than can be rendered on screen or even percieved by the human eye.

histogram A map of the distribution of tones in an image, arranged as a graph. The horizontal axis goes from the darkest tones to the lightest, while the vertical axis shows the number of pixels in that range.

hotshoe An accessory fitting found on most digital and film SLR cameras and some high-end compact models, normally used to control an external flash unit. Depending on the model of camera, pass information to lighting attachments via the metal contacts of the shoe.

hue The pure color defined by position on the color spectrum; what is generally meant by "color" in lay terms.

incident meter A lightmeter as opposed to the metering systems built into many cameras. These are used by hand to measure the light falling at a paticular place, rather than (as the camera does) the light reflected from a subject.

ISO An international standard rating for film speed, with the film getting faster as the rating increases. ISO 400 film is twice as fast as ISO 200, and will produce a correct exposure with less light and/or a shorter exposure. However, higher-speed film tends to produce more grain in the exposure, too.

JPEG (Joint Photographic Experts Group) Pronounced "jay-peg," a system for compressing images, developed as an industry standard by the International Standards Organization. Compression ratios are typically between 10:1 and 20:1, although lossy (but not necessarily noticeable to the eye).

layer In image editing, one level of an image file, separate from the rest, allowing different elements to be edited separately.

LCD (Liquid Crystal Display) Flat-screen display used in digital cameras and some monitors. A liquid-crystal solution held between two clear polarizing sheets is subject to an electrical current, which alters the alignment of the crystals so that they either pass or block the light.

macro A mode offered by some lenses and cameras that enables the lens or camera to focus in extreme close-up.

noise Random pattern of small spots on a digital image that are generally unwanted, caused by non-image-forming electrical signals.

open flash The technique of leaving the shutter open and triggering the flash one or more times, perhaps from different positions in the scene.

Raw files A digital image format, known sometimes as the "digital negative," which preserves higher levels of color depth than traditional 8 bits per channel images. The image can then be adjusted in software—potentially by three stops—without loss of quality. The file also stores camera data including meter readings, aperture settings, and more. In fact, each camera model creates its own kind of Raw file, though leading models are supported by software like Adobe Photoshop.

resolution The level of detail in a digital image, measured in pixels (e.g., 1,024 by 768 pixels), or dots-per-inch (in a half-tone image only, e.g., 1200 dpi).

RGB (Red, Green, Blue) The primary colors of the additive model, used in monitors and image-editing programs.

shutter speed The time the shutter (or electronic switch) leaves the CCD or film open to light during an exposure.

SLR (Single Lens Reflex) A camera that transmits the same image via a mirror to the film and viewfinder, ensuring that you get exactly what you see in terms of focus and composition.

slow sync The technique of firing the flash in conjunction with a slow shutter speed (as in rear-curtain sync). The result is that motion blur is combined with a moment frozen by the flash.

spotmeter A specialized lightmeter, or function of the camera lightmeter, that takes an exposure reading for a precise area of a scene.

telephoto A photographic lens with a long focal length that enables distant objects to be enlarged. The drawbacks include a limited depth of field and angle of view.

TIFF (Tagged Image File Format) A file format for bitmapped images. It supports CMYK, RGB, and grayscale files with alpha channels, and lab, indexed-color, and it can use LZW lossless compression. It is now the most widely used standard for good-resolution digital photographic images.

TTL (Through The Lens) Describes metering systems that use the light passing through the lens to evaluate exposure details.

Index

Picture Credits

6-7, 9, 13, 17-18, 20-21, 24, 27-29, 31, 33,
35-38, 44-46, 48-49, 58-60, 69-70, 74-76, 83-8
4, 86, 100 (Left), 103, 110, 112-116, 120,
124-125, 127-129, 131-134, 137, 143
David Nightingale
www.chromasia.com

2, 94
Steve Peel
www.flickr.com/photos/steve999

19
Andreas Overland
www.flickr.com/photos/andreasoverland

22
Dan Baggs
www.flickr.com/photos/baggage494

23
Kari McKay
www.km.scaremongering.net

53,55
Dave Wilson
www.photographynorthwest.com

56-57
Eli Turner
www.eilturner.com

62, 87
Adam Swords
www.adamswords.com

63, 65
Ben Willmore
www.thebestofben.com

64
Bo Helleskov
www.madphotoworld.com

66
Patrick Smith
www.patricksmithphotography.com

67
Matthias Pabst
www.pabst-photo.com

68
Heath Carney
www.heathcarney.com

71
Christine Glade
www.christinegladephotography.com

73
Chris Cupit
www.flickr.com/photos/drippy2009

79
Lluis Gerard
www.flickr.com/photos/djkubik

81(Top), 105, 106, 109
Chris Gatcum
www.cgphoto.co.uk

88-89
Keith Pytlinski
www.m5photography.com

90
Simon Gardiner
www.simongardiner.com

92-93
Jasper van der Meij
www.photo.shoq.com

95-97
Alan Sailer
www.flickr.com/photos/8763834@N02

98 (Bottom Right)
Andy Schonfelder
www.lightandtime.co.uk

117
Jemma Lambert
www.jemmalambert.co.uk

135
Brian Valentine
www.flickr.com/photos/lordv

4, 14, 15, 25, 26, 40, 41, 42, 43, 47, 50-51, 52,
54, 61, 77, 80, 81 (Bottom), 91, 98 (Bottom
Left), 99, 100 (Right), 101, 119, 121, 123
iStockphoto.com

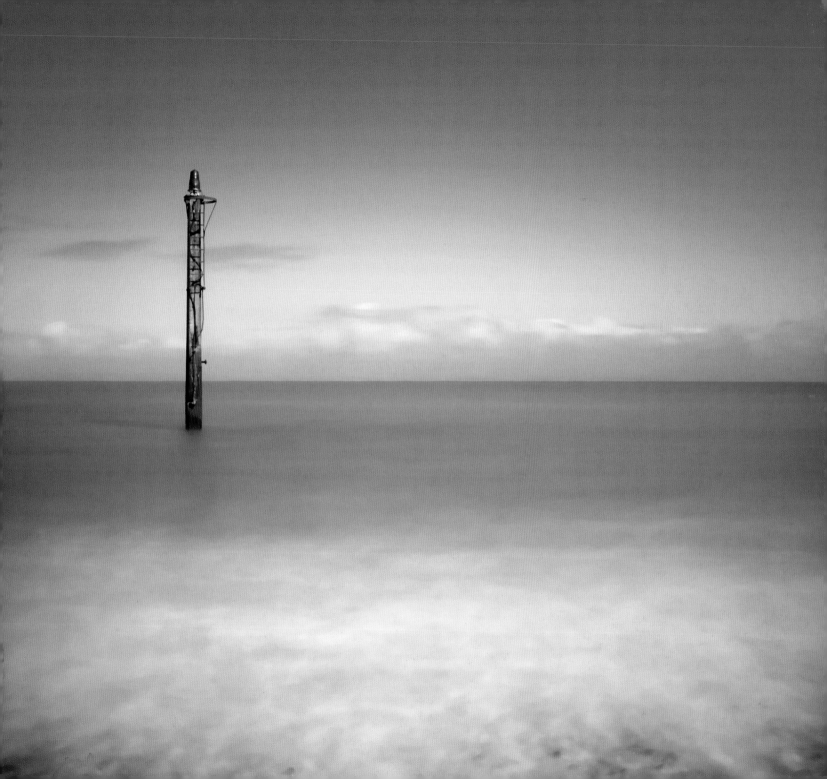

Acknowledgments

This book would not have been possible without the help of
a number of contributors who kindly agreed to let me to use
their work. As such, I would like to offer my sincere thanks
to all the photographers listed on the previous pages.

I would also like to thank Libby for proofreading various
sections of this book, helping select the images to
be included, and for being a much better wife than I
probably deserve. This book would not have been possible
without her.

And last, but not least, I would like to thank Chris Gatcum
at Ilex Press, both for inviting me to write this book in the
first place, and for helping out at a variety of points during
its construction.